Great Dixter

THEN & NOW

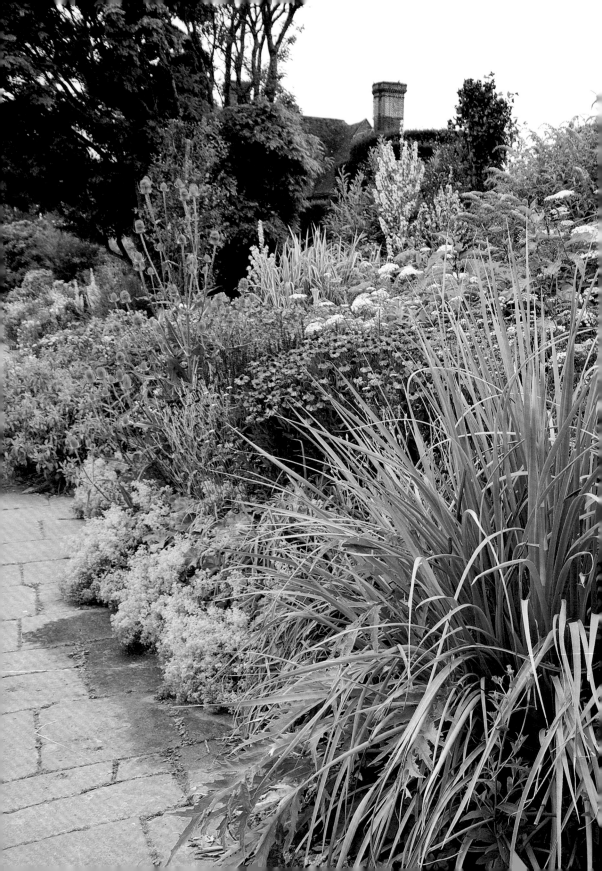

Great Dixter
THEN & NOW

PHOTOGRAPHS BY
CHRISTOPHER LLOYD
& CAROL CASSELDEN

WORDS BY FERGUS GARRETT

PIMPERNEL
PRESS LTD
www.pimpernelpress.com

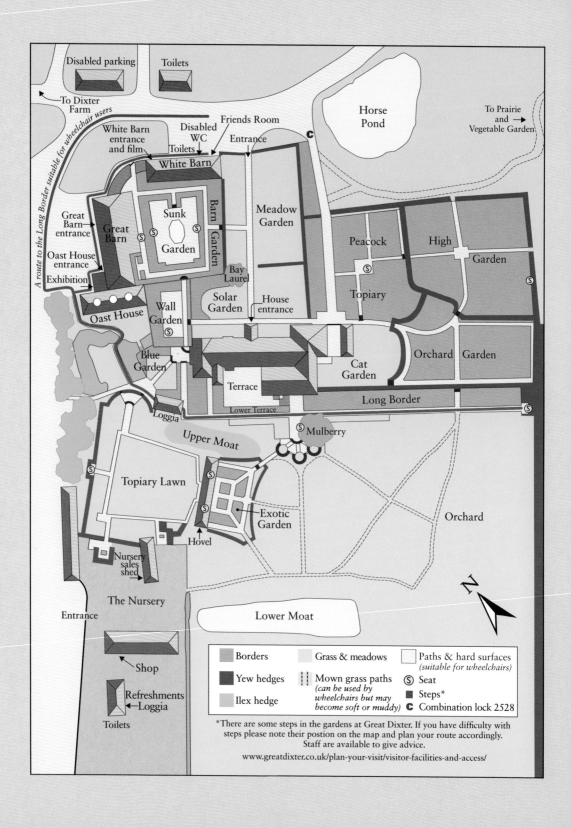

Disabled parking

Toilets

To Dixter Farm

Horse Pond

To Prairie and → Vegetable Garden

A route to the Long Border suitable for wheelchair users

White Barn entrance and film

Disabled WC

Friends Room

Toilets

Entrance

C

White Barn

Great Barn entrance

Great Barn

Sunk Garden

Barn Garden

Meadow Garden

Peacock

High

Garden

Oast House entrance

Exhibition

Bay Laurel

Topiary

Oast House

Wall Garden

Solar Garden

House entrance

Blue Garden

Cat Garden

Orchard Garden

Terrace

Long Border

Lower Terrace

Loggia

Mulberry

Upper Moat

Topiary Lawn

Exotic Garden

Orchard

Hovel

Nursery sales shed

The Nursery

Lower Moat

Entrance

N

Shop

Refreshments Loggia

Toilets

	Borders		Grass & meadows		Paths & hard surfaces *(suitable for wheelchairs)*
	Yew hedges	¦¦	Mown grass paths *(can be used by wheelchairs but may become soft or muddy)*	Ⓢ	Seat
	Ilex hedge			▦	Steps*
				C	Combination lock 2528

*There are some steps in the gardens at Great Dixter. If you have difficulty with steps please note their postion on the map and plan your route accordingly. Staff are available to give advice.

www.greatdixter.co.uk/plan-your-visit/visitor-facilities-and-access/

CONTENTS

Pimpernel Press Limited
www.pimpernelpress.com

Great Dixter Then & Now
© Pimpernel Press Limited 2021
Text © Fergus Garrett 2021
Illustrations © The Trustees of The Great Dixter
Charitable Trust
Except for those listed otherwise on the right of this page

A catalogue record for this book is available
from the British Library.

ISBN 978-1-910258-89-7

Typeset in Bell MT
Printed and bound in China
by C&C Offset Printing Company Limited

9 8 7 6 5 4 3

Acknowledgements

Many thanks to Kimberley and Bruce Peterson and
the Mercers' Company for funding the digitisation of
Great Dixter's prints; to Jo Hillier for all her hard work
cataloguing; to Carol Casselden, Jonathan Buckley
and Julie Weiss for their photographs. And to Victoria
Williams for her many years of devoted work at Dixter –
and for putting the book together.

Picture credits

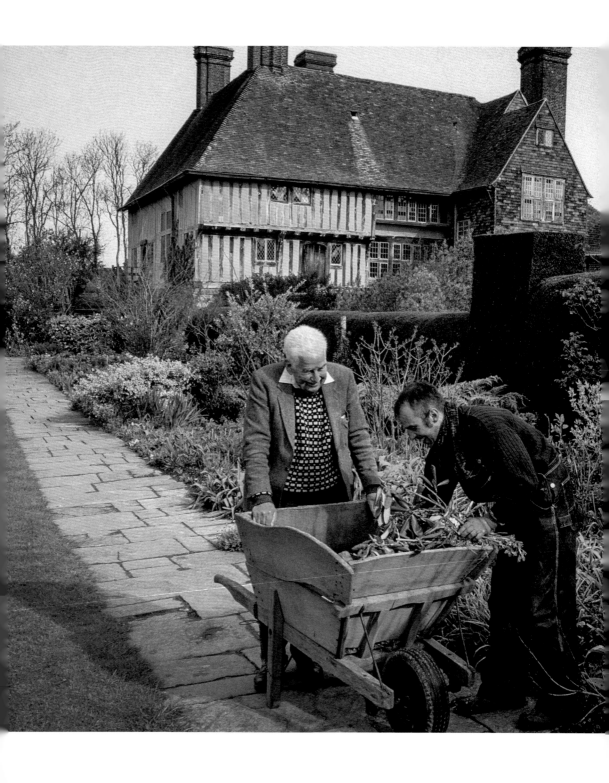

INTRODUCTION

The selection of photographs in this book shows how the garden at Great Dixter has developed since it was first laid out by Sir Edwin Lutyens and his clients Nathaniel and Daisy Lloyd in 1910. Though the garden has changed to reflect the fashions of the day – many of these set by Nathaniel and Daisy's son Christopher – there is nonetheless a strong line of continuity in the way in which it has been gardened. The baton has been handed on directly, from Daisy to Christopher and from Christopher to his head gardener, Fergus Garrett. Each has experimented and pushed boundaries while at the same time maintaining the underlying and distinctive character of the garden.

The earliest photographs depict in formal black and white the raw new planting masterminded by Daisy Lloyd after the First World War; then we are shown, through the appropriately rich medium of colour slides, the lushness and exuberance of Christopher Lloyd's borders in the second half of the twentieth century. The photographs of the garden as it is today reveal the same passion for unexpected combinations but using a looser, more interwoven approach, blurring the boundaries between the cultivated and the natural world.

Although Christopher's slides have preserved the brilliant colours of the garden, they have been a difficult resource to use. Numbering nearly four thousand items, the transparencies have been the subject of a long-running project to catalogue,

LEFT Christopher and Fergus working on the Long Border in the 1990s. Photograph by Jonathan Buckley.

clean and digitise the material. This has been
made possible through the work of cataloguer
Jo Hillier, photographic conservator Susie Clark
and James Stephenson of Cultural Heritage
Digitisation. Funding has been generously
provided by US friend Kimberly Peterson and in
the UK through the Mercers' Company. In the
summer of 2016 an exhibition of photographs
taken from the slides was held in the Great Barn
with sponsorship from Gardenscape Ltd and fine
printing carried out by King and McGaw.

Carol Casselden started taking photographs at
Great Dixter just before the death of Christopher
Lloyd in 2006. Her images document the garden
over a significant period when Fergus Garrett
created his own distinctive vision for the garden
rooted in what had gone before.

This publication is important because it is a
record of how Great Dixter has been enriched by
the interpretation of its different gardeners, as
well as by the maturing of plants and mellowing
of hard structures. Christopher Lloyd was one
of the most influential gardeners of the late
twentieth century and these images celebrate his
achievement by putting it in the context of what
came before and after. They show Great Dixter
as an inspiring place that expresses the magical
beauty of plants grown abundantly together in a
long-tended and much-loved historic setting.

VICTORIA WILLIAMS
GREAT DIXTER, JANUARY 2020

RIGHT Dixter gardeners *c.*1912.

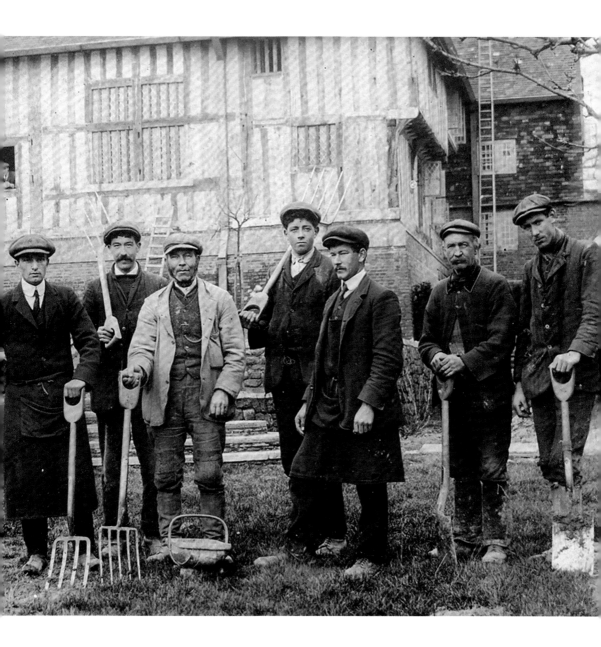

THE ENTRANCE DRIVE

The entrance drive in its naked state was the road leading to Dixter farm, with very little vegetation around the semi-natural horse pond. In the early photograph below you can clearly see the oak trees that flank the driveway, as well as a few significant trees within the Dixter property.

The oak trees are significantly larger now, although some tree work has had to be done to reduce the weight of the large overhanging branches. A mixed hedge lines the right-hand side of the driveway and an ever-increasing strip of *Sambucus ebulus* originally planted by Christopher Lloyd runs along the side of the road to the Horse Pond.

The long grass area within the garden fence shown in the image on the lower right has a mix of spring bulbs such as *Narcissus bulbocodium*, *Erythronium dens-canis* and *Narcissus minor* with primroses and wood anemones. They are followed by rushes and the water dropwort *Oenanthe crocata*. This area has retained its privacy even though the garden is open to the public. Rhododendrons and wild ferns populate the steep bank to one side, with large oaks and pine trees mixed in with aspen and alders.

BELOW Dixter *c.*1905, before its purchase by Nathaniel Lloyd and the building of the Lutyens extension.

RIGHT The gate to the Kitchen Drive with *Malus* 'John Downie', photographed by Christopher Lloyd in April 1997. The large wild pear tree on the left blew down in a strong gale before Christmas 2015.

BELOW RIGHT *Erythronium dens-canis* in long grass. Photograph by Carol Casselden, February 2009.

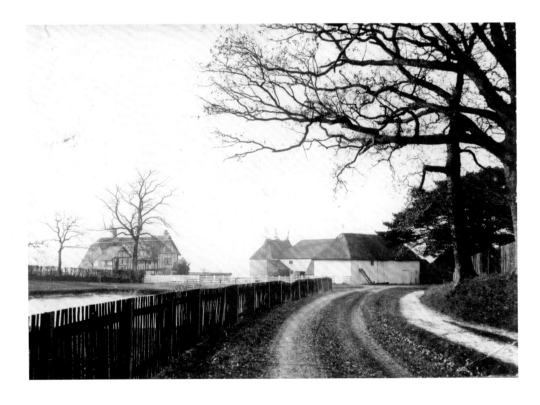

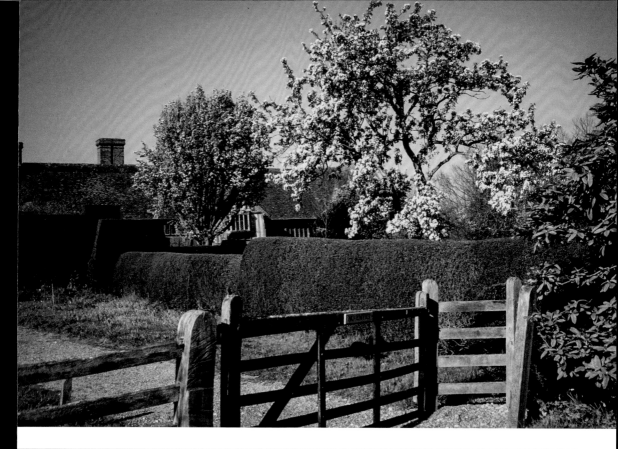
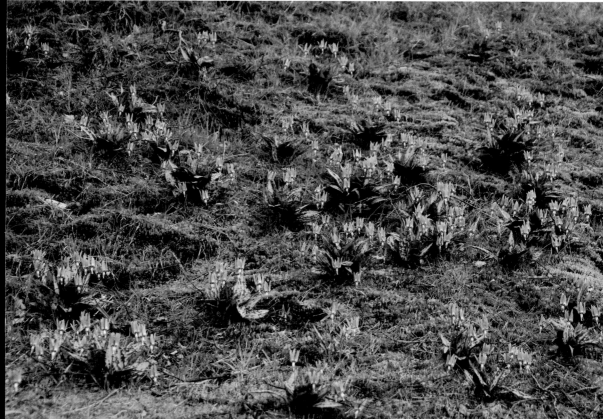

THE HORSE POND

Ponds where horses used to drink were a common feature in farms like Dixter. The Lloyds turned the Dixter Horse Pond into a semi-natural ornamental area with wildish planting and long grass coming right up to the water's edge. Wild orchids such as the common spotted seen in the photograph opposite happily self-sow here. The pond is regularly tidied up during spring and early summer to contain the spreading reeds to be seen in the picture on pages 14–15. *Gunnera tinctoria* flanks the pond on one side, with alders and willows on the other to give privacy from the road.

The pond contains several large carp and goldfish which were rehomed there (much to Christopher's disapproval).

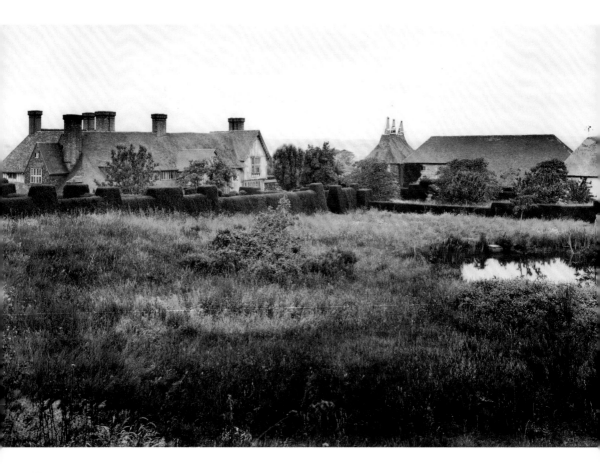

BELOW LEFT View of the house with the Horse Pond on the right, late 1920s.

BELOW The Horse Pond in September 1996. Photograph by Christopher Lloyd.

OVERLEAF The Horse Pond in April 2019. This photograph, by Carol Casselden, was taken before the annual tidy-up, in which the vegetation is reduced so that we can see enough water.

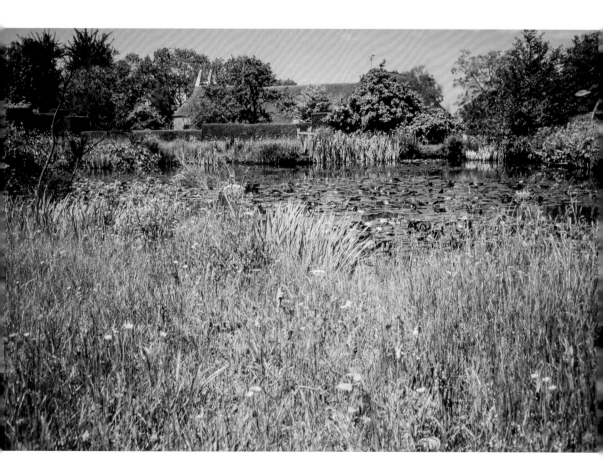

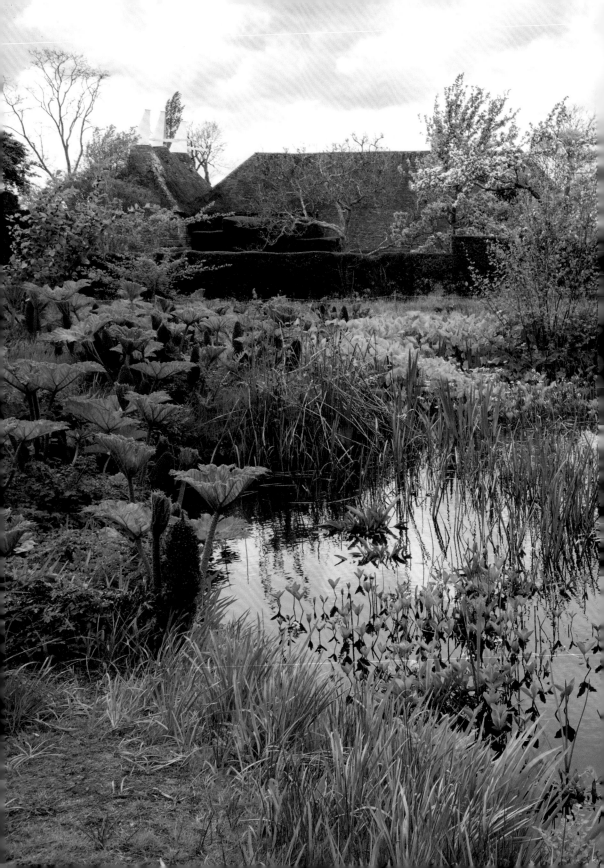

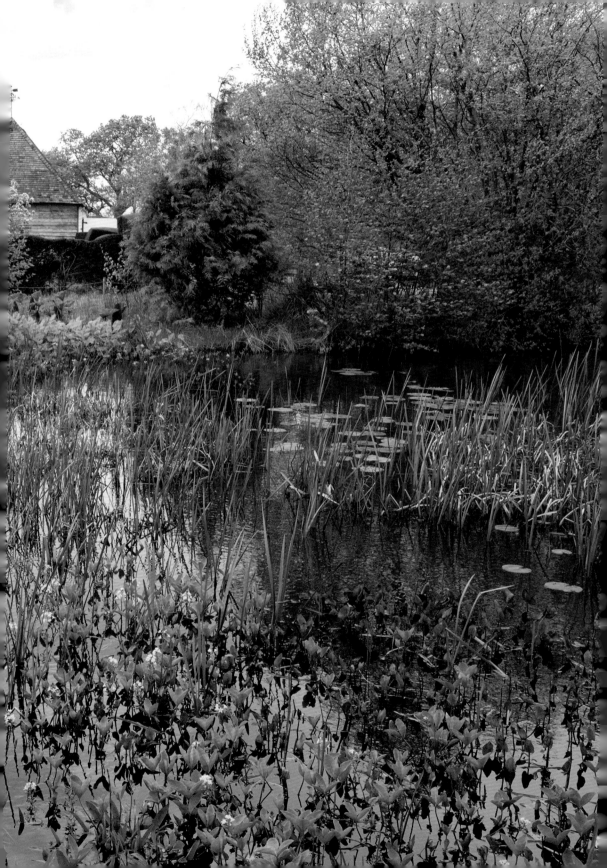

THE FRONT MEADOW

The entrance to the garden is through a little oak gate with a path of York stone leading to the Dixter porch. There are wild flower meadows either side of the path. These were developed by Daisy Lloyd with the help of her youngest son, Christopher, as seen in the photograph below. In this picture they are shown transplanting an orchid from Dixter woods. They added snowdrops into the shady areas, crocuses, a range of daffodils and North American camassias as seen in the image overleaf. The meadows have never stood still and experiments here are ongoing.

In the 1980s and 1990s the long grass on either side of the entrance provoked displeasure from many visitors expecting a striped lawn. Nowadays only a few visitors find the long grass disconcerting.

After the grass is cut in August, autumn crocuses and colchicums make a show.

BELOW LEFT Daisy and Christopher Lloyd in the Front Meadow, c.1925.

RIGHT Cutting the meadows in August 2018. All the clippings are bagged up and composted. Photograph by Julie Weiss.

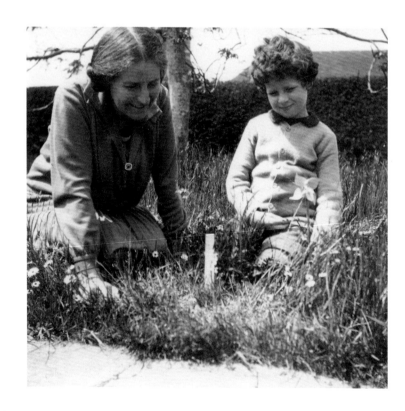

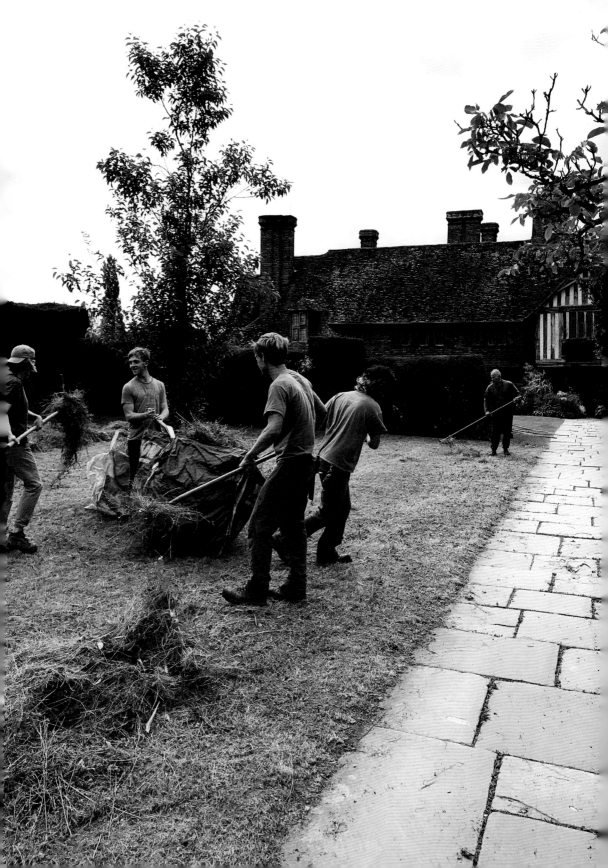

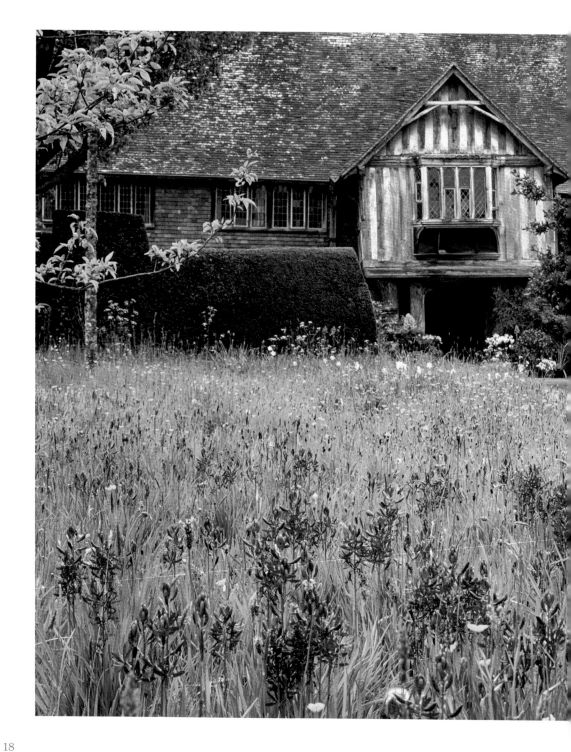

The Front Meadow
in Christopher
Lloyd's time.
Photograph by
Jonathan Buckley,
May 2002.

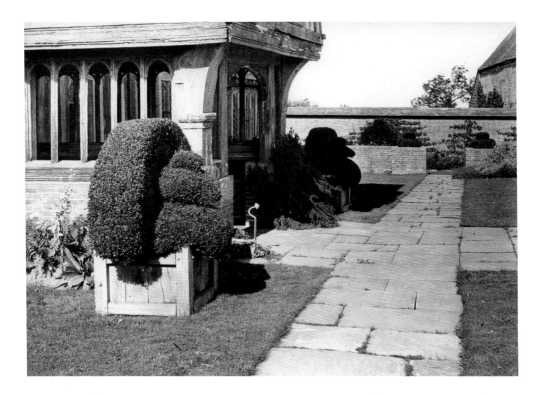

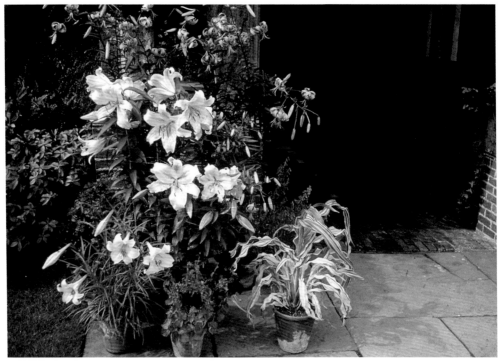

THE PORCH

LEFT The Porch in 1924, looking towards the Wall Garden.

BELOW LEFT Photograph by Christopher Lloyd, August *c.*1972.

BELOW Photograph by Carol Casselden, September 2016.

The topiary peacocks in their oak planters in the old black and white photograph have now spread out into amorphous shapes. If you look carefully today you can still see sections of the original wooden boxes they were planted in.

As time has passed the Porch displays have become more generous, increasing from seven to ten pots on either side to nearly thirty overflowing on to the path. The displays used to be done by Christopher with Fergus. Now everybody in the garden is involved and they are used as a teaching tool to make students more comfortable with different plant combinations, as well as providing a place where new varieties can be examined or trialled.

The image below left shows a typical Christopher Lloyd display, with lilies, salpiglossis and white-variegated maize. The more recent display shown below right has large pots of dahlias and cannas mixed in with shrubs, with grasses and annuals adding drama and providing a fuller display. The large box ball in the background is the now-obese peacock, which is rooted through to the soil beneath.

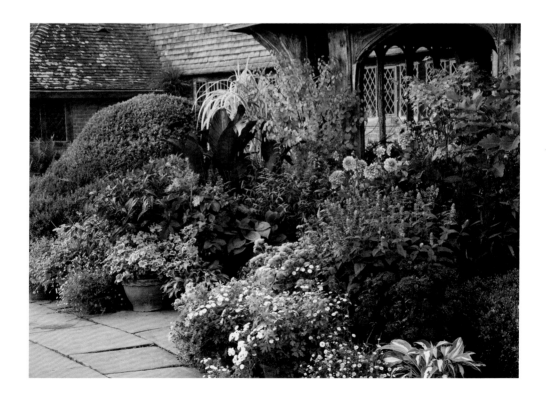

THE BARN AND SUNK GARDENS

The Barn and Sunk Gardens were designed by Christopher Lloyd's father, Nathaniel, after Lutyens had left this area as a flat lawn. The sunken octagonal pool and York stone seats recessed into grass banks make up the lower level, which is known as the Sunk Garden. The upper level is called the Barn Garden.

Nathaniel's design made the space far more interesting and gave strength and focus. The initial planting echoed the formality of the architecture but it became wilder under the influence of Daisy (who can be seen seated in the black and white picture on the right) and Christopher. Their looser style is in perfect contrast to the strong lines of the walls and stonework. Christopher revelled in this contrast and the same feel continues today.

BELOW View of the Barn Garden when it was a lawn, a photograph taken from the roof of the house, 1915.

RIGHT The Barn and Sunk Gardens, with Daisy Lloyd, seated, wearing Puritan dress, 1923.

BELOW RIGHT Looking towards the Great Barn. Photograph by Christopher Lloyd, September 1986.

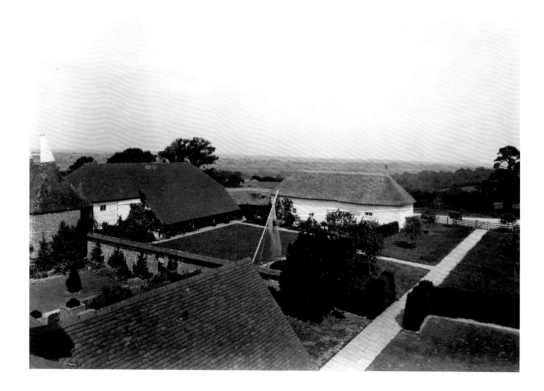

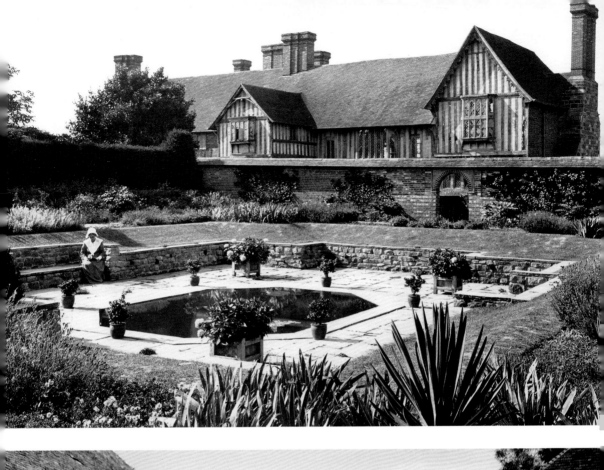

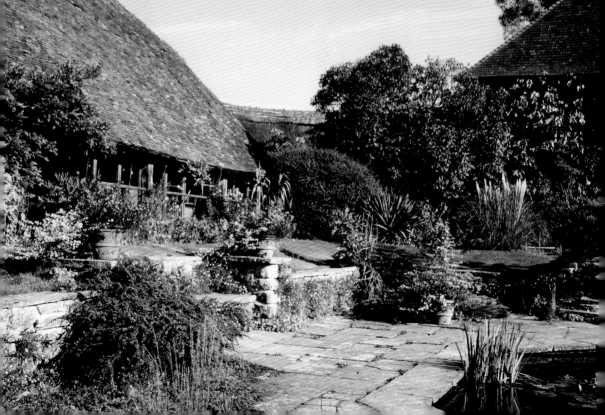

Originally the four corners of the Barn Garden were marked
by yuccas. Christopher replaced these with evergreen domes of
Osmanthus delavayi. Large bushes of *Cotoneaster horizontalis* and
tree peonies that he planted spill out of the walls, trailing down
to the Sunk Garden wall.

In the borders surrounding the Sunk Garden he dotted
bedding pockets for plants such as the sunflowers to be seen in
the image below. These are *Helianthus* 'Valentine', a compact
branching variety with pale lemon flowers. The pockets are
still there today, as are the terracotta pots of pelargoniums and
interesting annuals which sit on walls and on the floor of the
Sunk Garden. The planting is a mix of the architectural and
the informal.

The Sunk Garden should look informal and comfortable, but at
the same time there must not be too much vegetation masking
and detracting from the original design. The space has a feeling
of intimacy and enclosure but from time to time larger shrubs
have to be pruned back harder.

Great crested newts still live happily in the Sunk Garden pond.

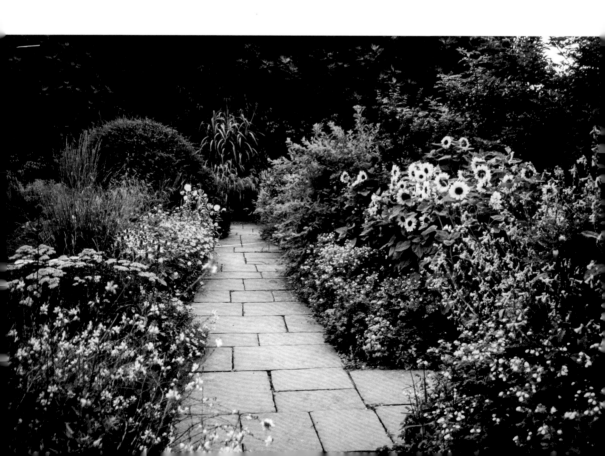

BELOW LEFT Path with sunflowers. Photograph by Christopher Lloyd, August 1994.

BELOW The Barn and Sunk Gardens. Photograph by Carol Casselden, July 2016.

OVERLEAF The Barn and Sunk Gardens. Photograph by Carol Casselden, April 2017.

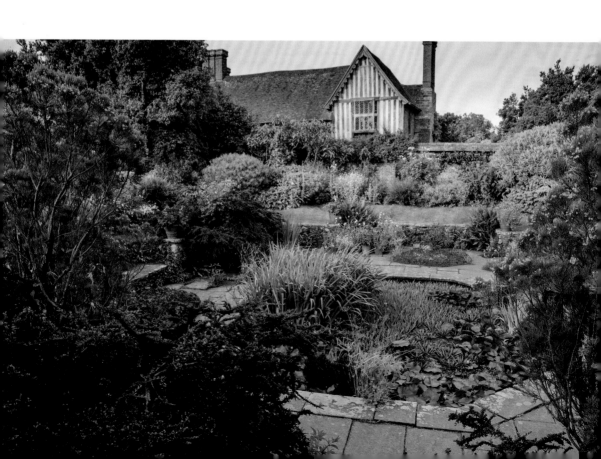

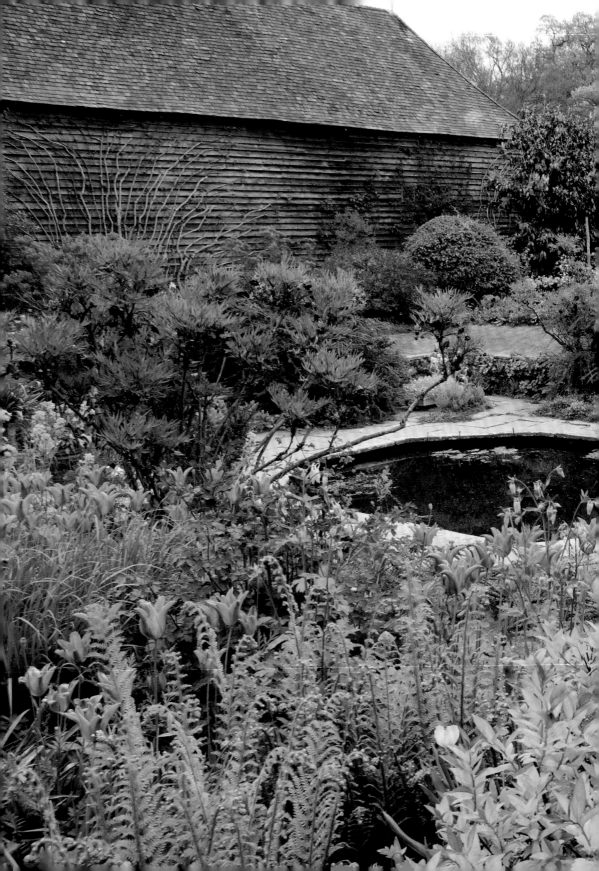

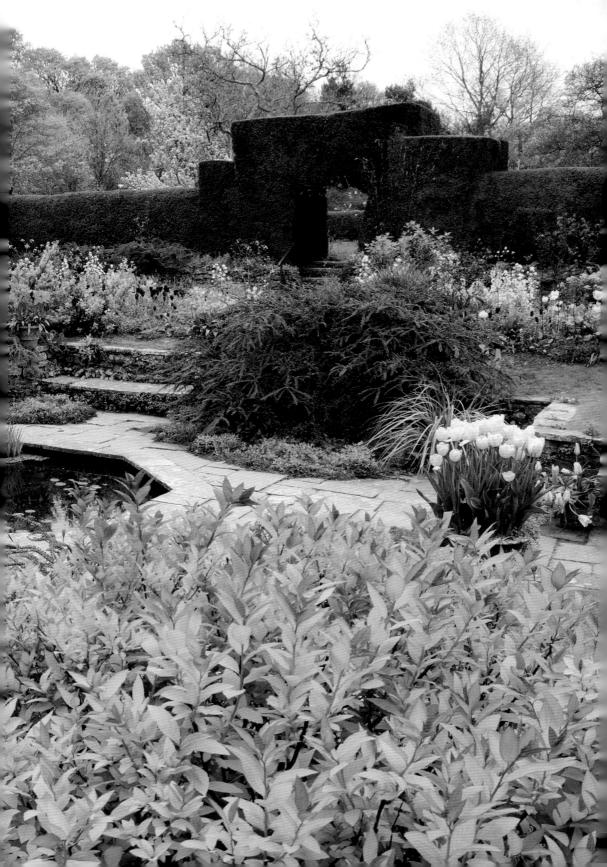

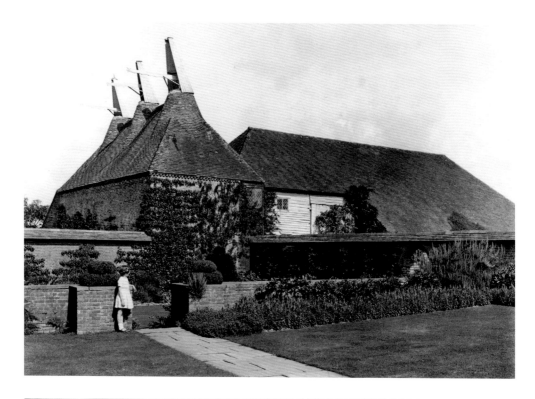

THE SOLAR GARDEN

LEFT Letitia Lloyd by the steps to the Wall Garden, 1927.

BELOW LEFT An experiment with yellow nasturtiums. Photograph by Christopher Lloyd, August 1978.

BELOW Photograph by Carol Casselden, September 2016.

The Solar Garden in front of the house is the main bedding area. The bed started off L-shaped and rather narrow, but as perennial Japanese anemones and various shrubs were planted into it more and more of the grass was swallowed up and the bed is now curved. Annuals and bedding plants are replaced here up to three times a year, with seldom any repetition and always an element of surprise.

The plants are always grown at Dixter, from seed or cuttings, with a lot of juggling of material to get the timing of the display right. The photograph at lower left shows a Christopher Lloyd experiment with yellow nasturtiums in combination with white Japanese anemones. The photograph below shows a Fergus experiment with a mix of rudbeckia, *Dahlia coccinea* 'Lady Mary Keen', *Browallia americana* and the dark-leaved *Dahlia* 'Twyning's After Eight'. The spirit of learning by trial and error continues.

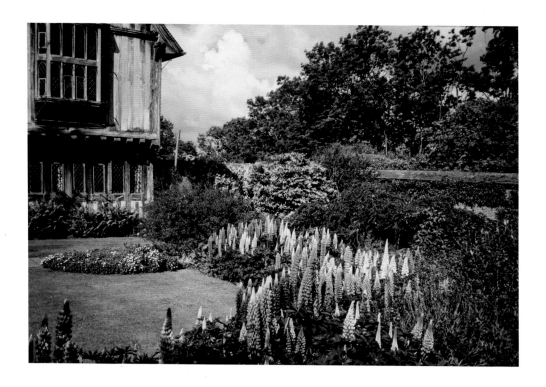

These are two further pictures of Christopher's planting in the Solar Garden. One shows a sweep of a lupin seed mix which would have had tulips in between to give a display earlier in the year. The other is a striking show of wallflower 'Fire King' with 'West Point' tulips backed by tulip 'Queen of Sheba' and threaded through with forget-me-nots in the spring. This was planted in the early 1990s with wallflowers grown at Dixter that had been sown in June during the previous year.

ABOVE Lupins in the Solar Garden, June 1988. Photograph by Christopher Lloyd.

RIGHT 'West Point' and 'Queen of Sheba' tulips and 'Fire King' wallflowers in the Solar Garden, with forget-me-nots, May 1994. Photograph by Christopher Lloyd.

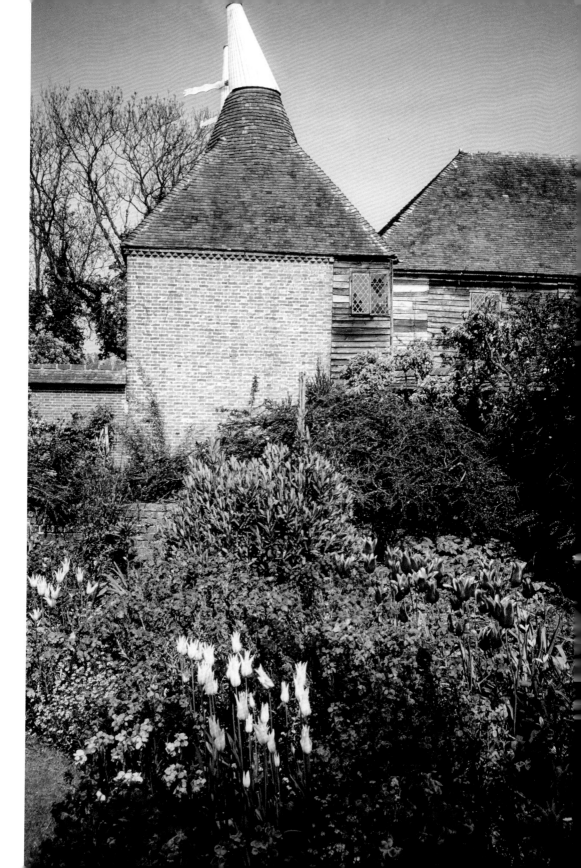

THE WALL GARDEN

The early black and white photograph of the Wall Garden opposite shows box topiary pieces on top of the walls by the steps leading down from the Solar Garden. These disappeared some time ago and were replaced with bedding plants on one side and herbaceous perennials on the other.

The lawn in the Wall Garden was taken up in 1998 to be replaced by a pebble mosaic of Christopher Lloyd's two dachshunds (seen overleaf). This was designed by Miles Johnson and installed by Maggy Howarth and Mark Davidson. The borders within this space are multi-layered, with a range of bulbs starting with snowdrops followed by daffodils and tulips such as the 'Spring Green' variety seen in the picture below right. These are then gently overtaken by the oncoming *Paris polyphylla*, *Kirengeshoma palmata* and *Boehmeria cylindrica*. Self-sown forget-me-nots, *Smyrnium perfoliatum* and honesty are informal fillers.

Cotoneaster horizontalis has sown itself into the crumbling lime mortar of the wall separating this space from the Solar Garden. The *Choisya* × *dewitteana* 'Aztec Pearl' flowering in the picture below has been replaced by *Ligustrum japonicum* 'Rotundifolium', with a *Daphne pontica* spilling on to the path in the centre.

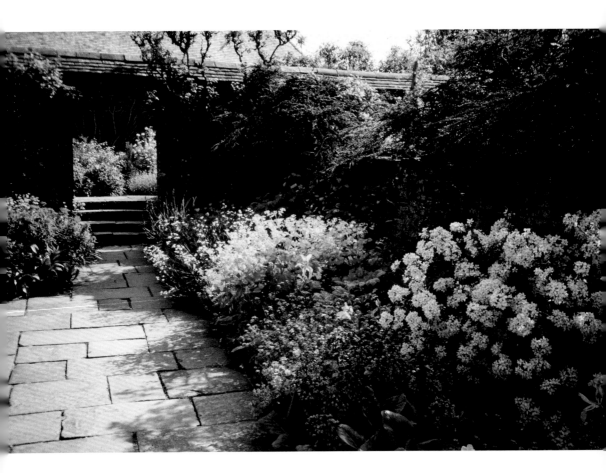

BELOW LEFT Path and border in the Wall Garden, May 2000. Photograph by Christopher Lloyd.

RIGHT The north front of Great Dixter from the Wall Garden, 1912.

BELOW RIGHT Path and border in the Wall Garden, April 2017. Photograph by Carol Casselden.

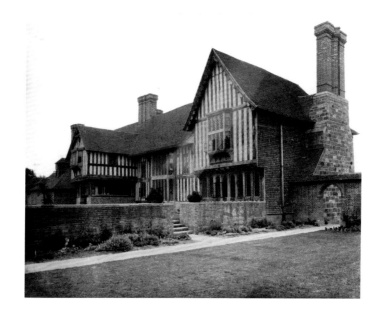

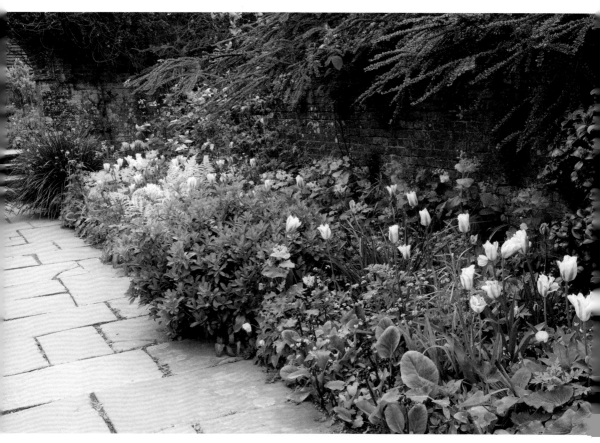

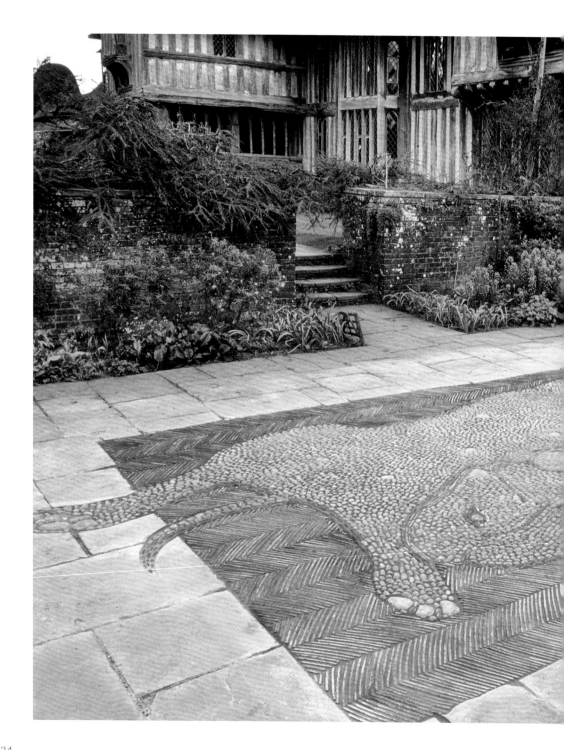

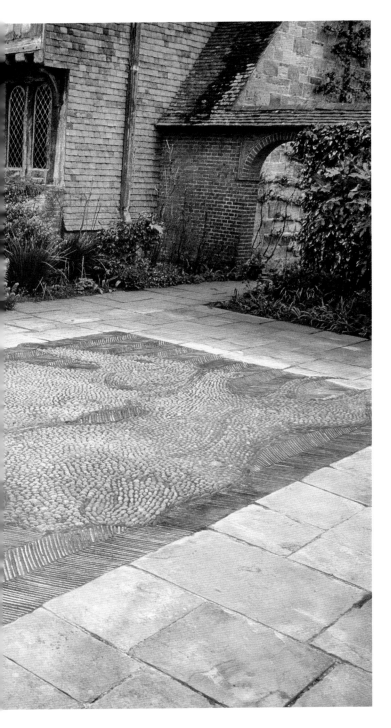

Dachshund mosaic in the Wall
Garden. Photograph by Jonathan
Buckley, *c.*1998.

THE BLUE GARDEN

The *Malus floribunda* shown in the photograph on the right died of honey fungus in 2007 and has been replaced with another crab apple, which is planted several metres away. The carcass of the original tree was left as standing deadwood, still underplanted with *Epimedium pinnatum* subsp. *colchicum*. Now, in 2020, it has collapsed.

The area in front of the tree, which had been unsatisfactory for many years, has now been filled with the strong shapes of quirky conifers, along with astelias, bamboos and grasses.

BELOW Planting in the Blue Garden, spring 2020. Photograph by Fergus Garrett.

RIGHT Fergus and Christopher on either side of the crab apple, in April 1998. Photograph by Jonathan Buckley.

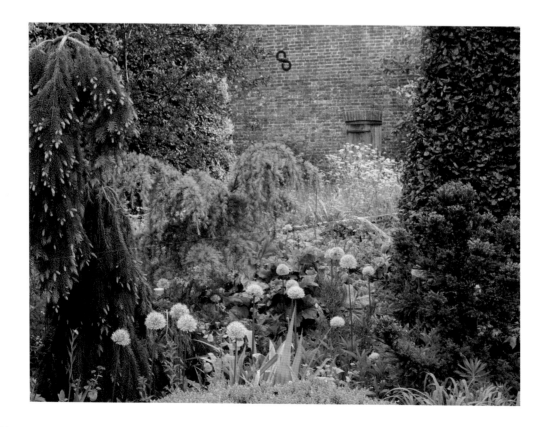

THE TOPIARY LAWN

Lutyens left the area west of the Rose Garden hovel as a formal lawn, and Nathaniel Lloyd used it as a putting green. The children were given pocket money for weeding it on a regular basis. Topiary was added to the space by Nathaniel, but as some of this succumbed to wet feet Christopher replaced the dead yew bushes with other shrubs, including bamboos, smoke bushes and cephalotaxus. The current policy is either to rejuvenate the older yews as they grow weaker, or to replace them with younger stock.

One Sunday morning in the mid-1990s, while sitting on the 'family pew' drinking champagne, one of Christopher's guests had an idea of turning the formal putting lawn into a meadow. Christopher agreed; and now the sward is home to thousands of common spotted orchids.

The mowing of the Topiary Lawn meadow follows the same regime as in the main meadows at Dixter, with the first cut around mid-August after the orchids have ripened their seed followed by a later cut in November, when the topiary pieces are also trimmed.

The nearest field of yellow rapeseed seen in the photograph above right is now pastureland grazed at low density for biodiversity.

BELOW View of the house from the Topiary Lawn, late 1920s.

RIGHT The Topiary Lawn, old farm buildings and countryside, in May 1987. Photograph taken from the roof by Christopher Lloyd.

BELOW RIGHT Orchids in the Topiary Lawn, June 2018. Photograph by Carol Casselden.

OVERLEAF The Topiary Lawn in May 2015. Photograph by Carol Casselden.

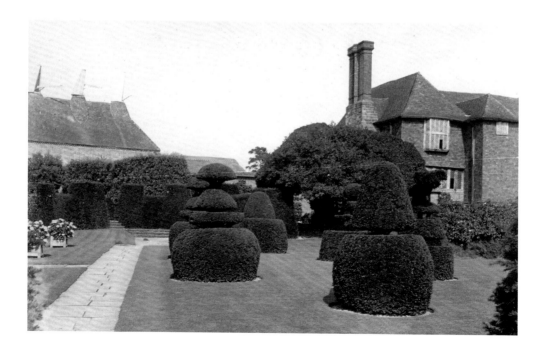

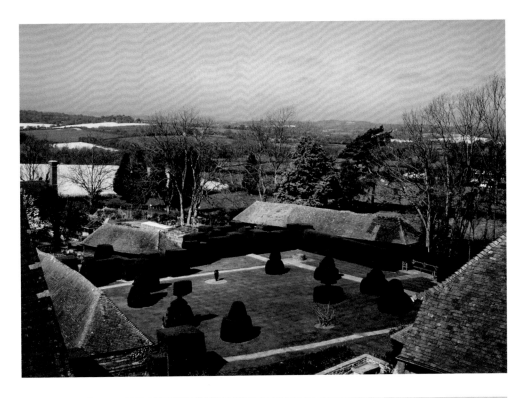

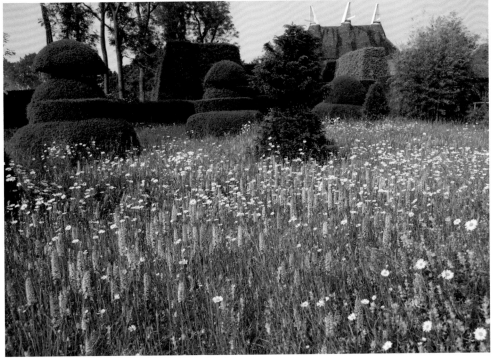

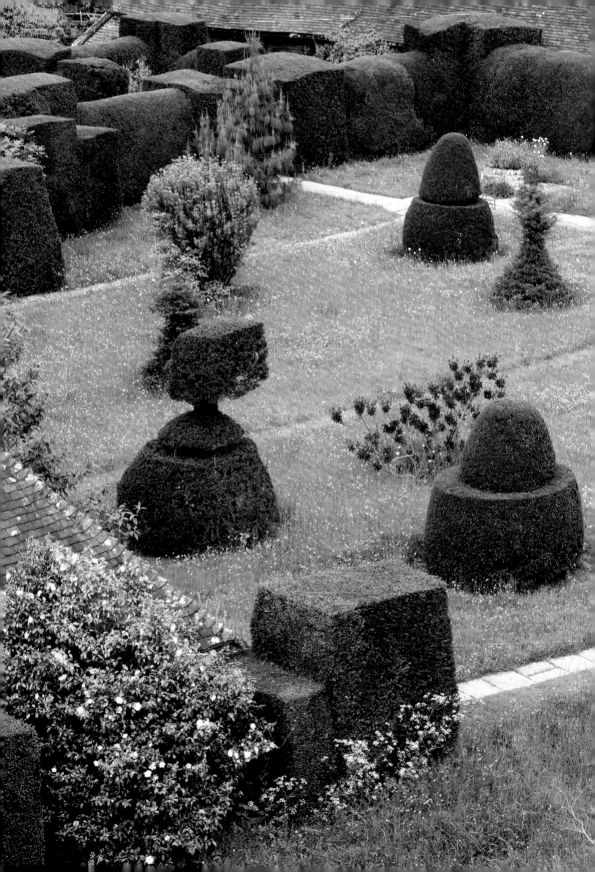

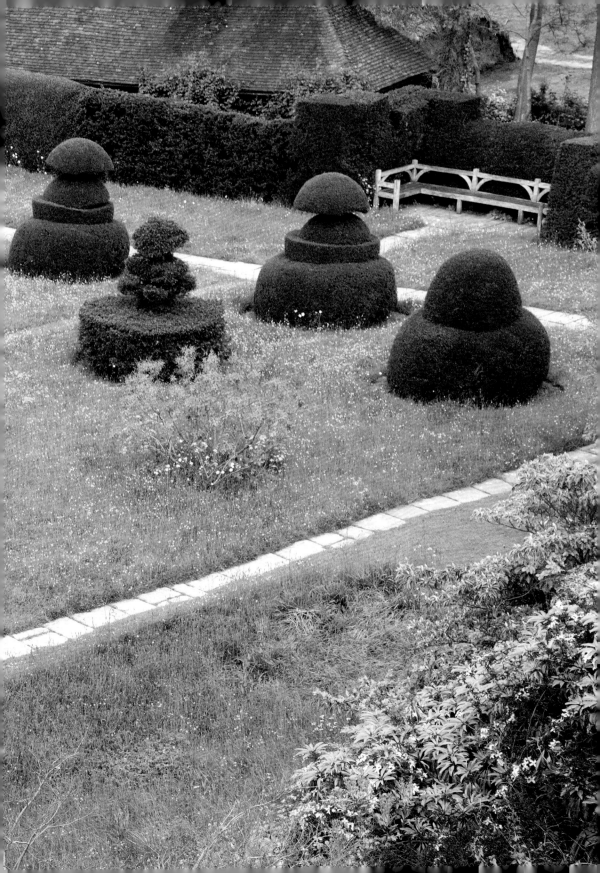

THE ROSE GARDEN, NOW THE EXOTIC GARDEN

Lutyens's Rose Garden, enclosed on three sides with yew hedging and on the fourth by what used to be an old cattle shed, was made up of a series of beds surrounded by York stone paving.

Up until the 1990s this remained a rose garden, but then, under Christopher's instructions, most of the roses were ripped out, leaving only eleven bushes. Following this the garden was planted up with bananas, cannas, dahlias and kniphofias as well as colourful annuals such as the magenta *Petunia* 'Purple Wave' and yellow corn marigold, *Glebionis segetum. Verbena bonariensis* seeded throughout the garden.

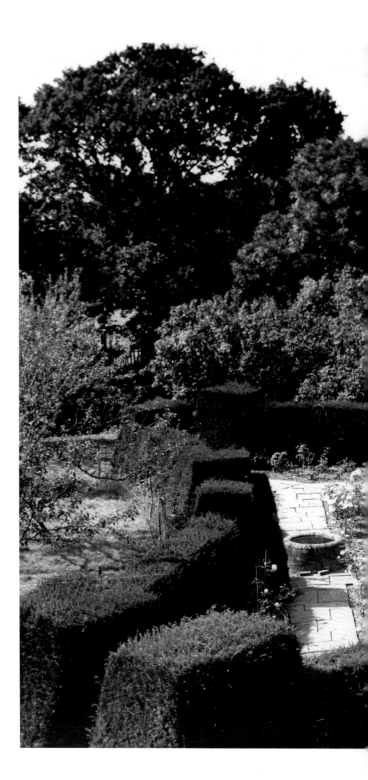

The Rose Garden in the 1920s.

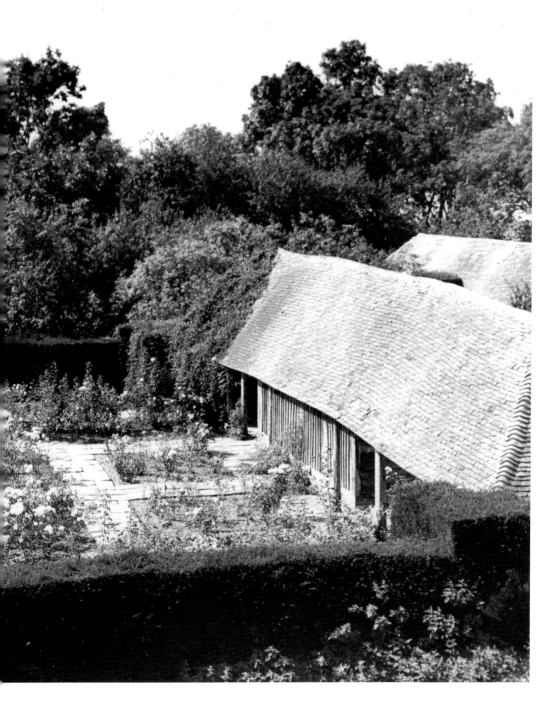

BELOW The Exotic Garden in August 1996.
Photograph by Christopher Lloyd.

RIGHT The Rose Garden, August 1978. Photograph
by Christopher Lloyd.

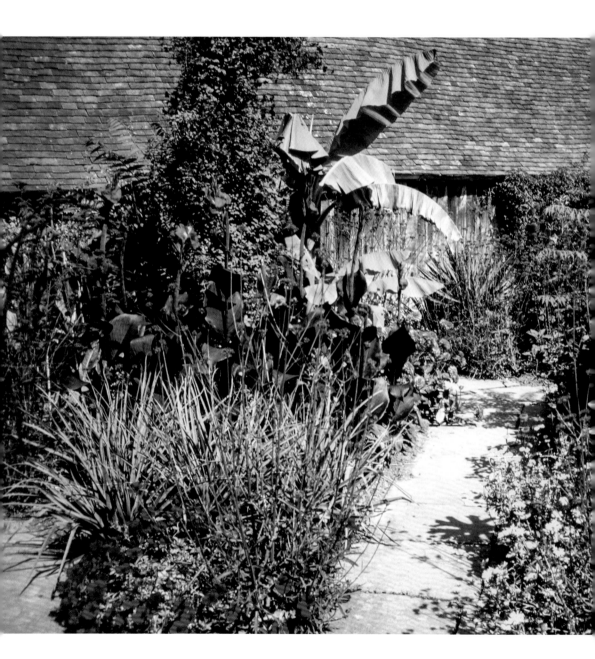

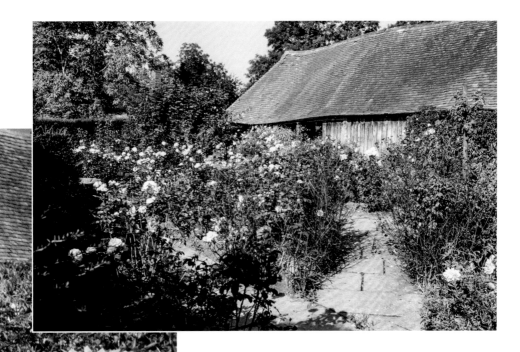

Renamed the Exotic Garden, for some time it was a jazzy mix of bright flowers rubbing shoulders with bright foliage, until Fergus took a left turn and started playing off varied tones of green with contrasts of texture and shape. Conifers were introduced to add a different feel. The experiments within this space continue and in future cannas and dahlias may be back to give a more colourful display.

In recent years the planting has overflowed on to the pathways, with the canopy closing in overhead to give a more jungly feel. The garden is pulled apart before the first frost. Some of the plants, such as the giant Japanese bananas, are protected *in situ*, wrapped in straw and hay, while the cannas and dahlias are lifted and stored in the cellar of the house to be brought out in March and potted up.

OVERLEAF The Exotic Garden in October 2017. Photograph by Carol Casselden.

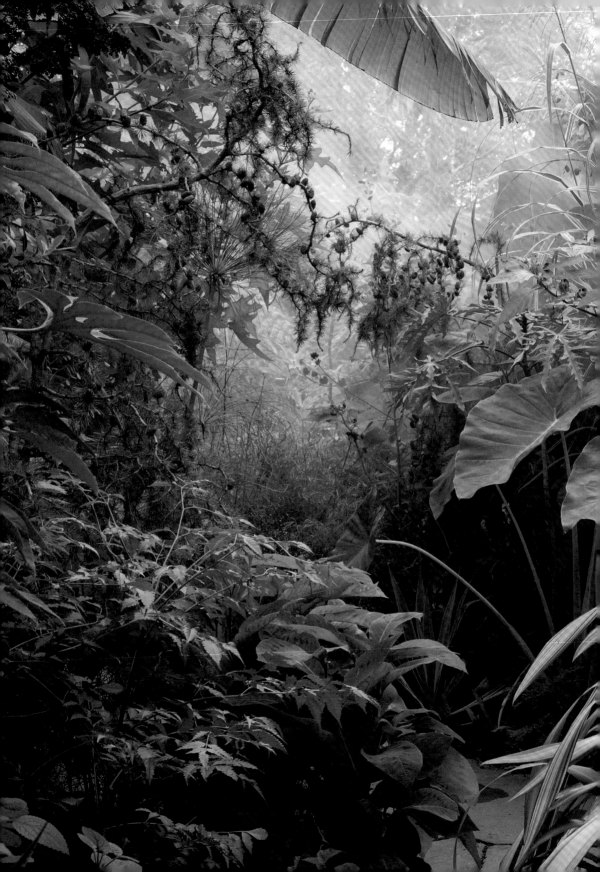

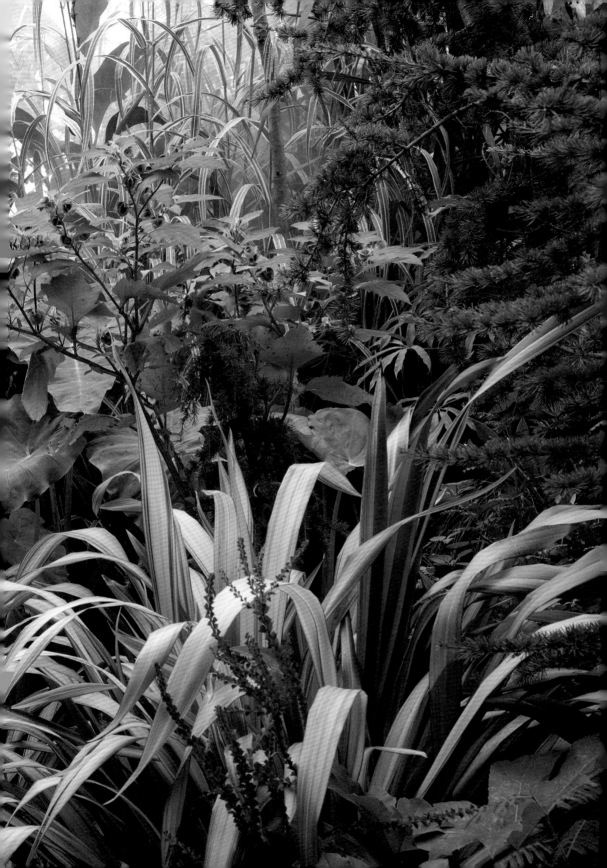

THE LOWER TERRACE

On the lower terrace there used to be two black mulberries, planted around 1910, that flanked the path leading from the house to Lutyens's concave and convex steps. The one on the right-hand side of the path blew down in a great storm. The remaining tree that you can see, with its branches supported by chestnut posts, is due for rejuvenative pruning to stop it from splitting apart.

The *Magnolia* × *soulangeana* 'Lennei' on the left in both pictures has to be constantly kept off the path in order to stop foot traffic straying on to the grass – though we do like catching a glimpse of the Long Border through a tunnel of magnolia flowers and foliage. The *Magnolia stellata* seen in flower in the older picture still exists although it is now partly swallowed up by a self-sown *Cotoneaster horizontalis*.

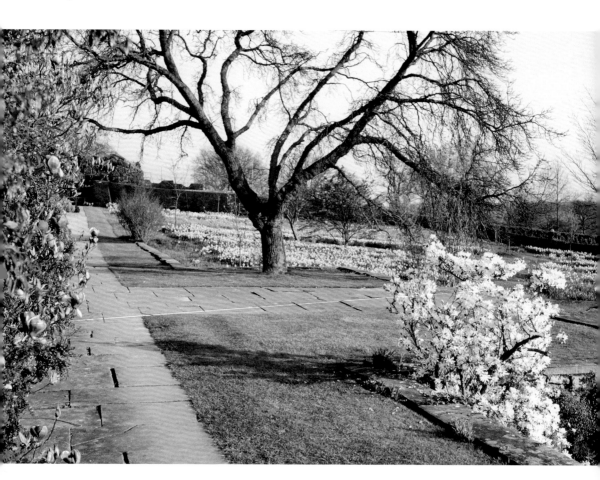

BELOW LEFT The Lower Terrace. Photograph by Christopher Lloyd, April 1984.

BELOW The same view photographed by Carol Casselden in April 2019. The worn grass paths are not always repaired, as bare ground provides a good nesting site for some solitary bees.

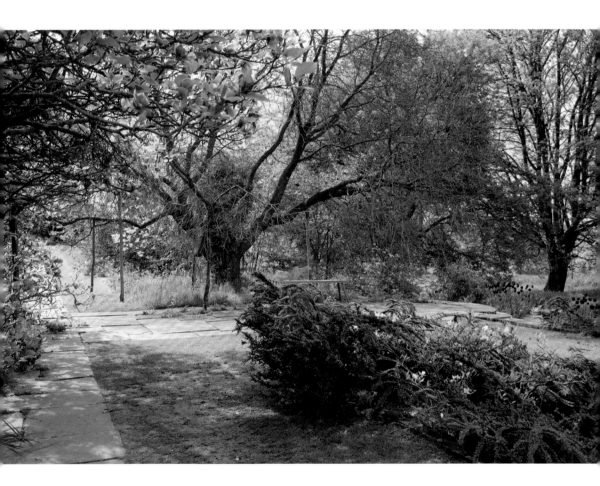

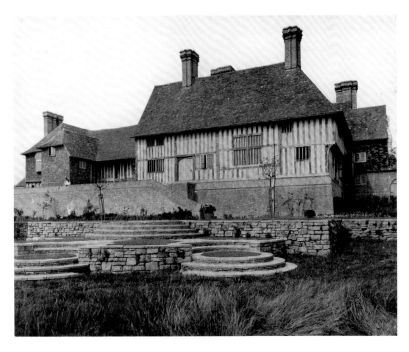

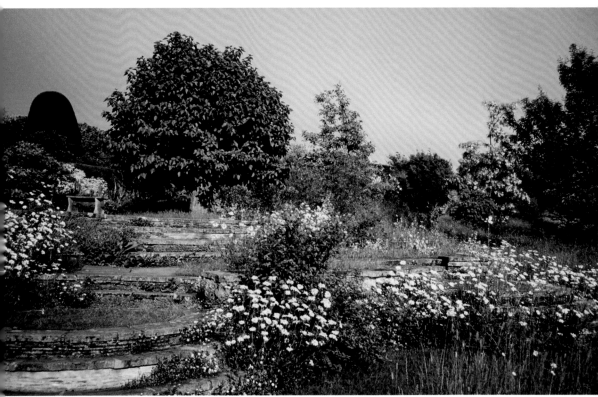

THE CIRCULAR STEPS

LEFT The Circular Steps below
Yeoman's Hall shortly after the
restoration of the house in 1912.

BELOW LEFT Daisies on the
Circular Steps. Photograph by
Christopher Lloyd, 1992.

BELOW Zinnias on the Circular
Steps. Photograph by Carol
Casselden, September 2014.

OVERLEAF Cacti and succulents
in the pads above the steps.
Photograph by Carol Casselden,
August 2016.

Lutyens's concave and convex Circular Steps have long grass
flowing right up to them. Ox-eye and Mexican daisies are at
home in the cracks between the stones.

The pads above the steps were formal lawn, which was
strimmed and trimmed on a weekly basis, until Christopher,
inspired by Thomas Hobbs's 'hump of desire' in Vancouver,
Canada, decided to bed out with cacti and succulents. These
have an architecture that complements the steps.

The bedding changes. Sometimes bigger cacti and succulents
are used, but summer rains make their husbandry difficult,
with some of the wet-sensitive plants succumbing to the
high moisture levels. The trick is to take them in at the end
of August, which leaves the steps bare. The area is one of
constant experiment, and the plants chosen can range from
dwarf zinnias to a collection of conifers, all set off by the strong
architecture of the steps.

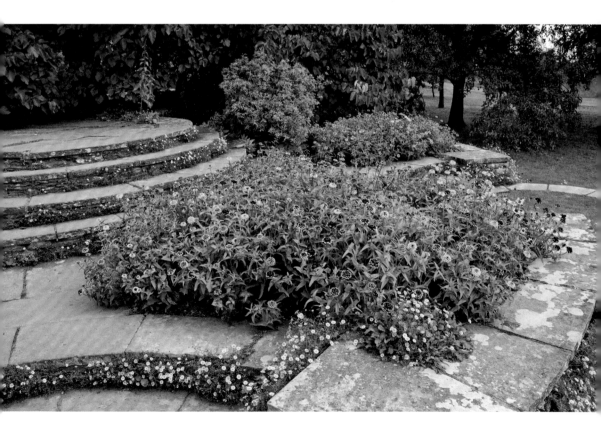

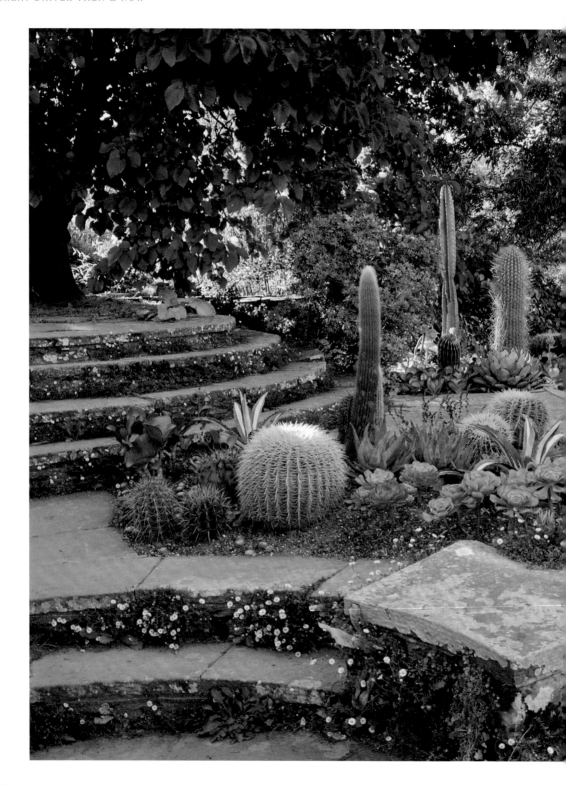

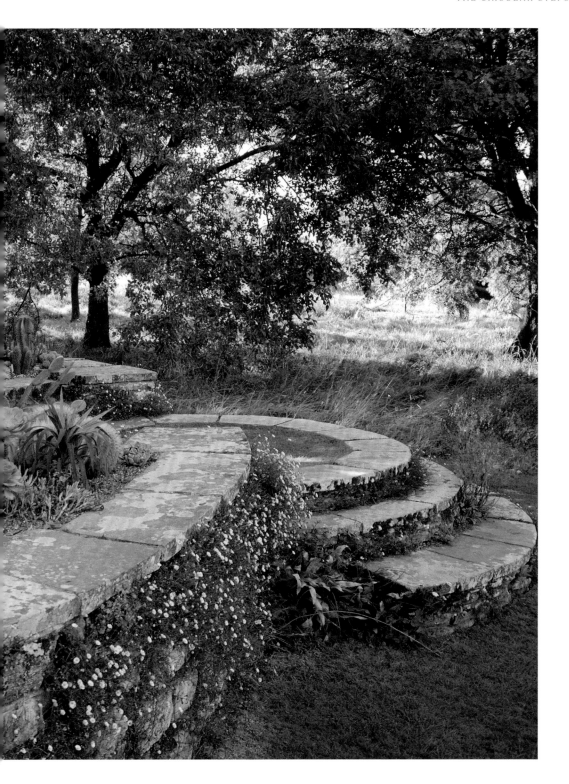

BELOW The Orchard, *c*.1930.

TOP RIGHT The Circular Steps from the Orchard, May 2009. The trees have grown and filled in.

BELOW RIGHT Wheelbarrow path through the Orchard. Photograph by Carol Casselden, May 2008.

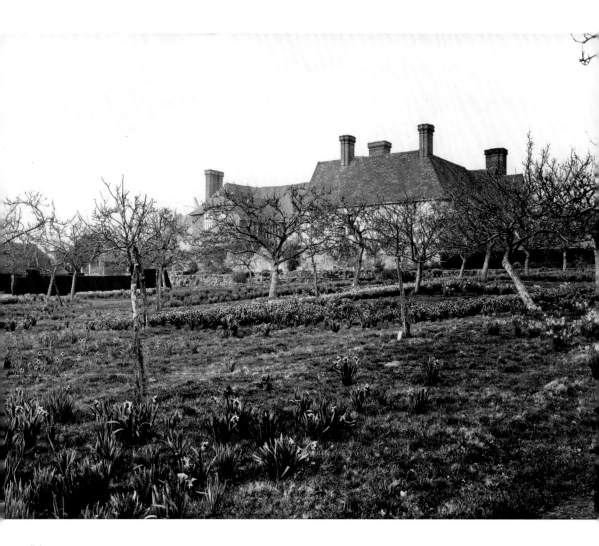

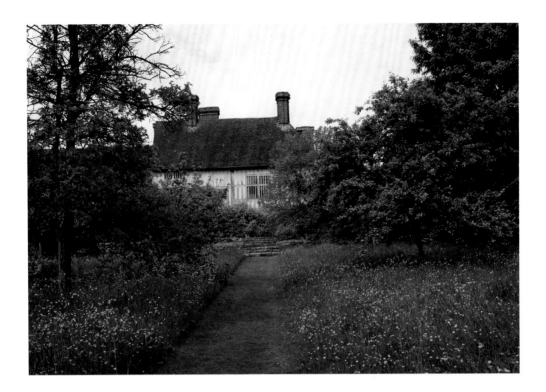

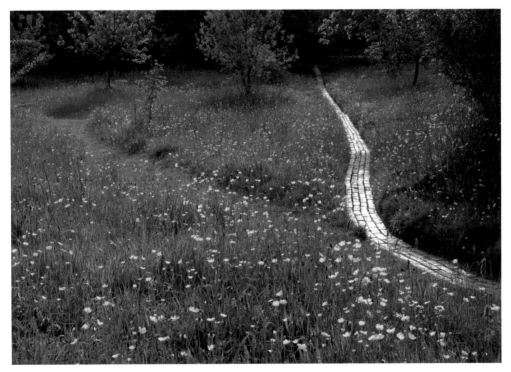

THE LONG BORDER

The Long Border was Daisy Lloyd's pet in the early days, always backed by a yew hedge. Early photographs show the young yews. As time went by, the border became fuller and more layered as more and more bulbs were added. The variegated weigela is the oldest plant in the border.

Trees and shrubs dominate the two colour photographs by Christopher Lloyd. The variegated sweet chestnut was the first tree that Christopher made Fergus dig out of the garden. Doing this opened up a view of the house from the path.

This part of the Long Border is in two halves. The first section, shown in the top photograph opposite, has the Yeoman's Hall visible, whereas in the second section the view of the house used to be blocked by the large gleditsia shown in the lower image. This tree succumbed to honey fungus and was dug out in 2018. The ground is being rested before a different tree takes its place.

This iconic border remains a multi-layered, multi-season mixed border that has peaks and troughs of interest throughout the year. The picture overleaf shows the border at the peak of its summer season.

BELOW The Yeoman's Hall and Long Border in 1914.

TOP RIGHT *Allium cristophii* in the Long Border. Photograph by Christopher Lloyd, July 1986.

BELOW RIGHT The Long Border from the Lutyens seat. Photograph by Christopher Lloyd, July 1995.

OVERLEAF The Long Border and the east front of the house. Photograph by Carol Casselden, *c.* July 2014.

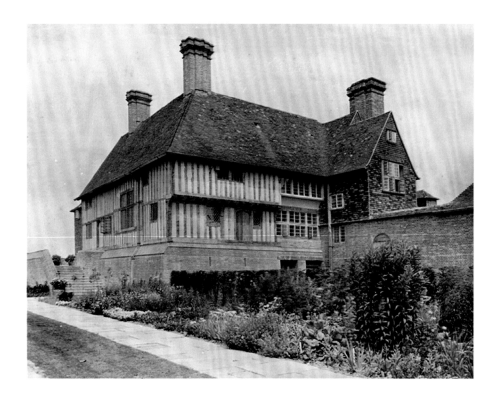

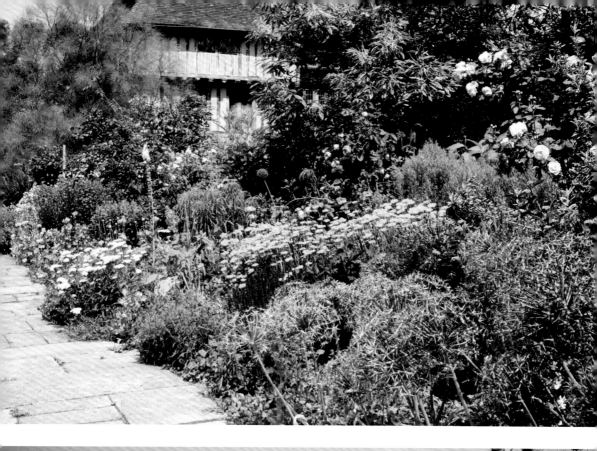
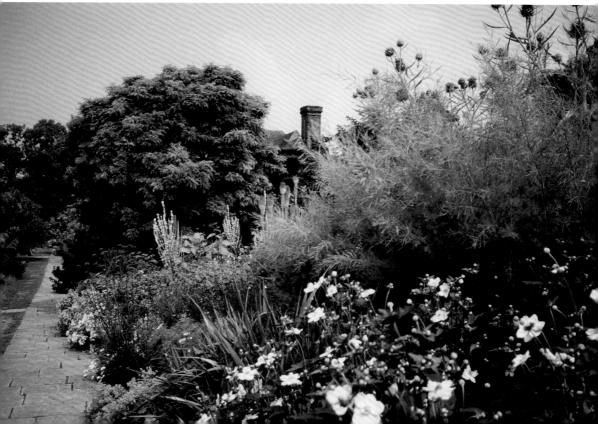

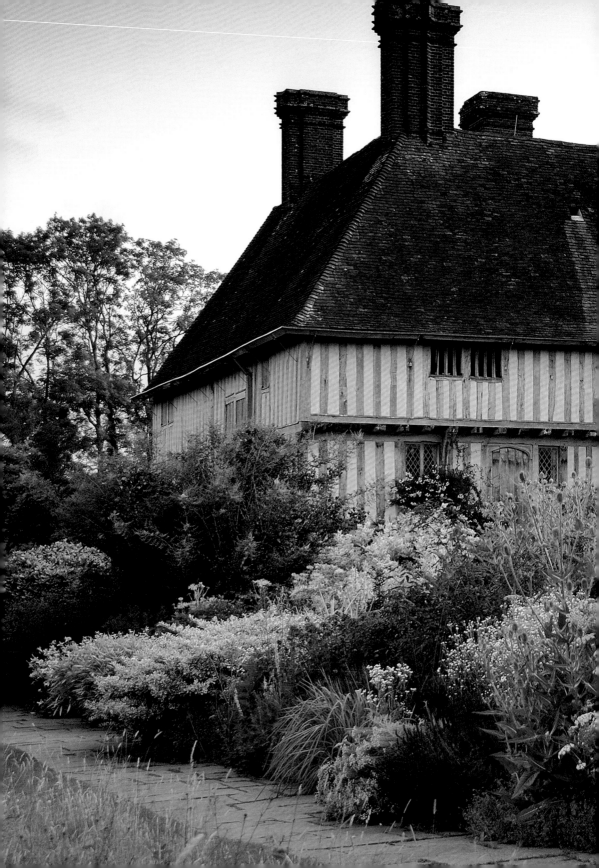

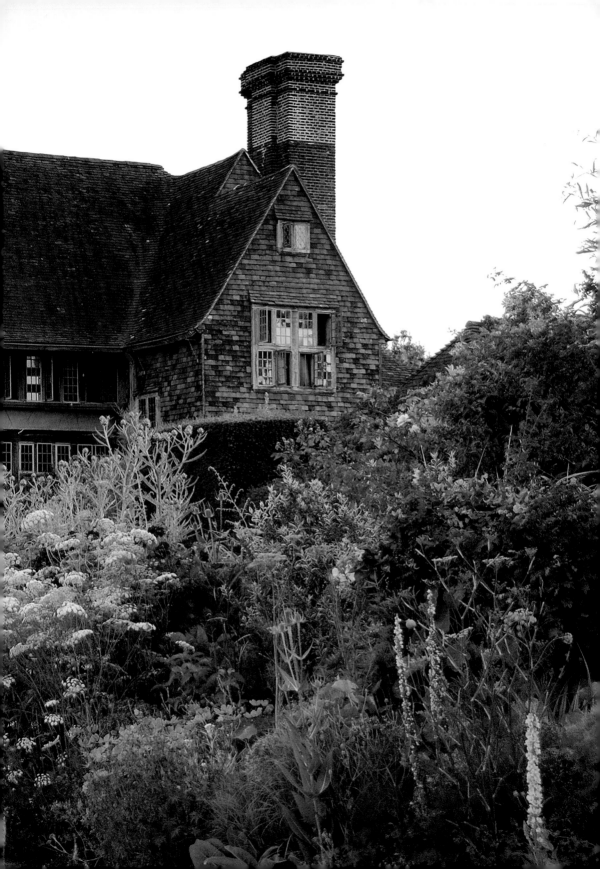

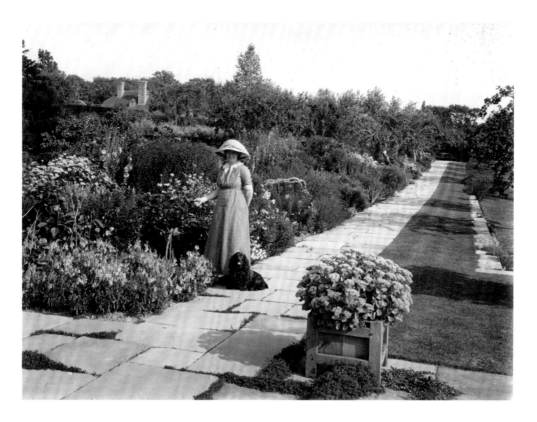

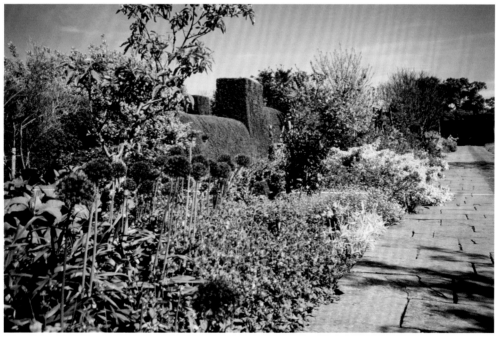

LEFT Daisy Lloyd by the Long Border, *c.*1917.

BELOW LEFT *Allium hollandicum* 'Purple Sensation' and *Silene dioica* 'Flore Pleno'. Photograph by Christopher Lloyd, May 1994.

BELOW The same view, now with the addition of George Russell lupins. Cow parsley (*Anthriscus sylvestris*) can also be seen self-sowing in the border (this was not allowed in Christopher's day). Photograph by Carol Casselden, May 2017.

The black and white image shows Daisy Lloyd standing by the Long Border around 1917, before the yew hedge masked the view of the cottages at Higham. The pictures below left and below show the border at more or less the same time of year, with *Allium hollandicum* 'Purple Sensation' flowering in both. The repetition of yellow through the border makes it visually richer, with plants spilling out on to the paths to break the hard edge of the paving.

Mown grass and York stone separate the border from the orchard meadow. Bedding pockets within the border are ever-changing: forget-me-nots overtake tulips in the picture by Christopher Lloyd, while in the more recent image tulips and alliums are fronted by the ever-colourful *Pleioblastus viridistriatus* (syn. *P. auricomus*).

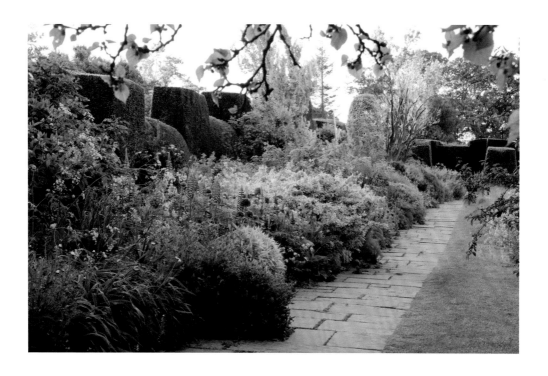

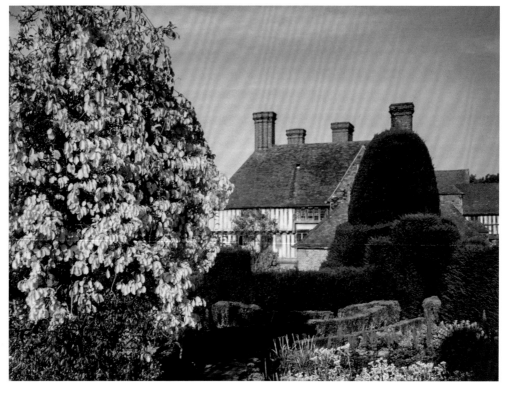

THE ORCHARD GARDEN

LEFT Nathaniel Lloyd standing by his recently planted yew hedges, *c.*1917.

BELOW LEFT The large yew known as 'Big Dick', which dominated views of the house for many years. Photograph by Christopher Lloyd, October 1971.

BELOW View from the Orchard Garden. Photograph by Carol Casselden, June 2011.

The early black and white photograph opposite shows Nathaniel Lloyd standing beside the old yew tree which he had limbed back to the core to create the topiary piece seen in the image below. The curving path he is standing on was eventually lined with box hedges, and after the opening of the nursery in the 1950s the space beyond was planted with stock.

The old yew topiary piece started going back in the 1990s, finally dying shortly after Christopher Lloyd's death in 2006. A new yew has been planted adjacent to the archway. This is currently being shaped and in a few years' time will make a prominent feature on Dixter's skyline.

The nursery stock beds on either side of the box hedge have a midsummer focus, with hardy geraniums, phloxes and the candelabras of verbascums (*V. olympicum*).

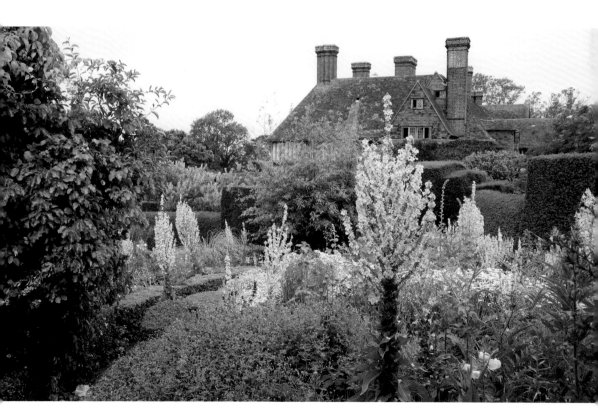

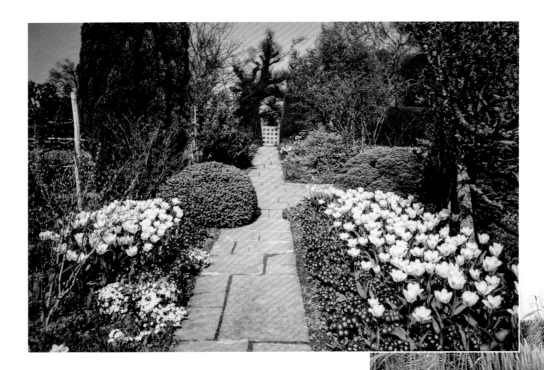

THE HIGH GARDEN

The High Garden has narrow beds on either side of the cross path, with espalier pears that block the working squares beyond. The pears, planted in the early twentieth century, are "Doyenné du Comice".

The conifer that appears at the top left of both pictures was given to Christopher Lloyd by his student Tom Wright in the 1950s. It was meant to be a dwarf form of *Chamaecyparis lawsoniana* 'Ellwood's Gold', but has now grown to be an enormous tree, more than 50 feet/15 metres tall. The variegated weigela in the picture above has recently been pruned to reduce its size.

The bedding area seen in the top image planted with white 'Purissima' tulips and red polyanthus still exists, although the planting is overall more informal. The espalier pears are now old and tired but are kept for their architectural value. The *Hebe* 'Pewter Dome' seen more prominently in the older picture has also been cut back to rejuvenate it. *Hebe cupressoides* 'Boughton Dome' on the opposite side of the path occupies a greater area but has split in the middle.

The lattice gate was reproduced by Jono Lloyd in the 1990s, to replace an earlier version.

LEFT 'Purissima' tulips wIth polyanthus 'Crescendo Bright Red'. Photograph by Christopher Lloyd, April 1992.

OVERLEAF The same view in May 2019. Photograph by Carol Casselden.

BELOW Planting up stock beds in the High Garden, *c.* 2015.

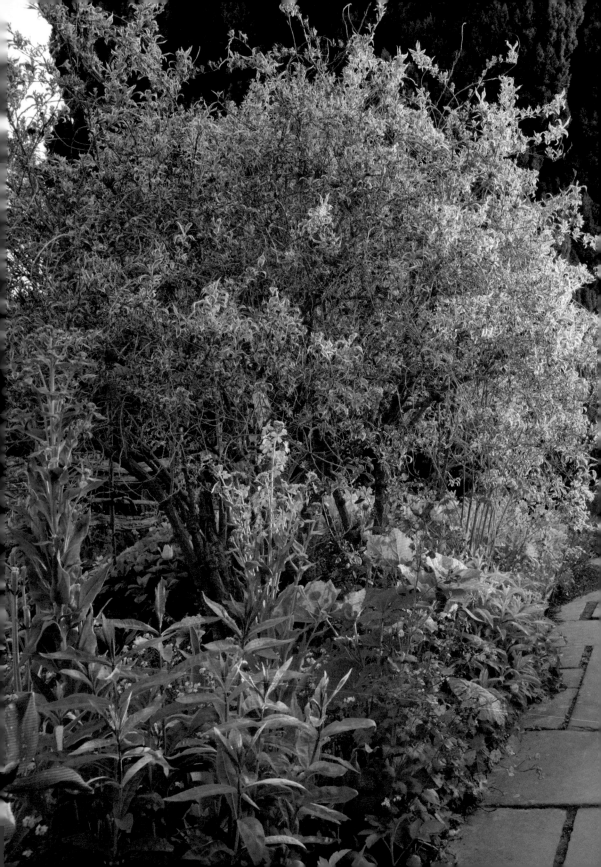

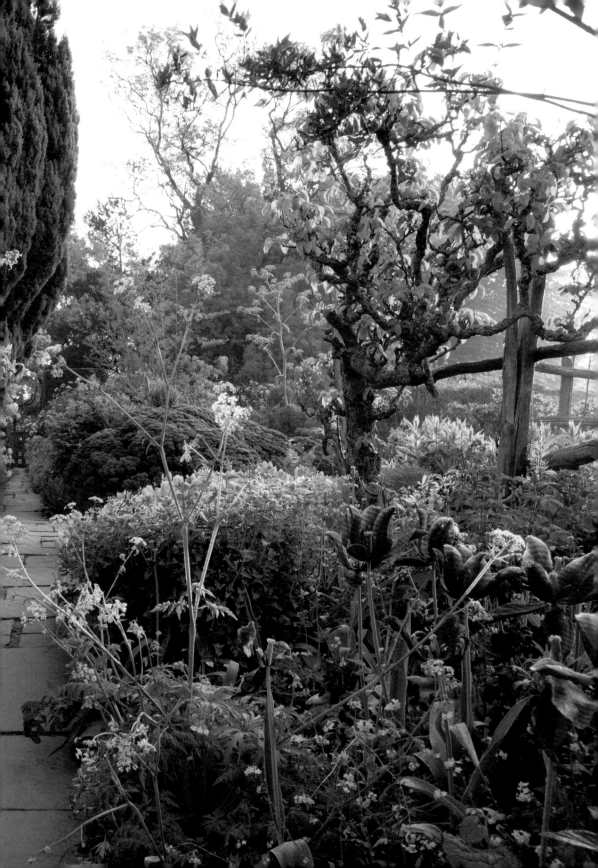

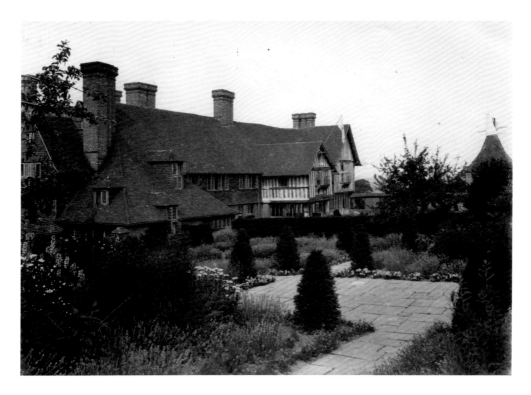

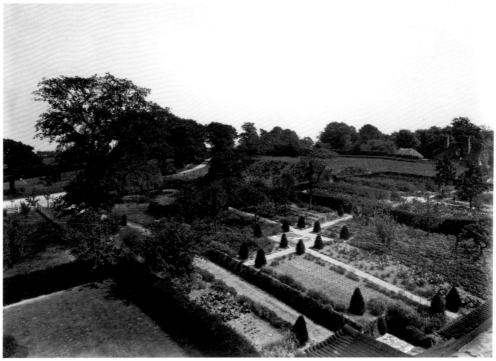

THE PEACOCK GARDEN

LEFT The Peacock Garden, looking towards the entrance porch, 1918.

BELOW LEFT A view of the Peacock Garden taken from the house roof showing the beginnings of the topiary peacocks, c.1917.

BELOW View of the house with the mature peacock topiary. Photograph by Christopher Lloyd, October 1996.

OVERLEAF Looking towards the house. Photograph by Carol Casselden, July 2014.

PAGES 72–73 The peacock topiary newly clipped in autumn. Photograph by Carol Casselden, October 2012.

This section of the High Garden was a weak part of Lutyens's design but was strengthened by Nathaniel Lloyd's introduction of a medley of birds in yew topiary. Lavender hedges joined the pieces and for a long time this garden was known as the Lavender Garden. As the lavender plants died out in the heavy wet soil they were replaced by a light-textured Michaelmas daisy, *Symphyotrichum lateriflorum* var. *horizontale*.

The birds have now all become peacocks and the straight rows of mother plants have been replaced by more informal planting. This still serves as a stock area for the nursery.

The picture overleaf shows how the planting in these stock areas has been stretched to extend the season, with columns of mauve-coloured *Thalictrum* 'Elin' and the yellow candelabras of *Verbascum olympicum* providing interest between groups.

The picture on pages 72–73 shows the Peacock Garden in its late glory when summer colour meets autumn at the end of October, and winter seed heads are embraced. The informality of the planting sets off the crisp lines of the newly clipped peacocks.

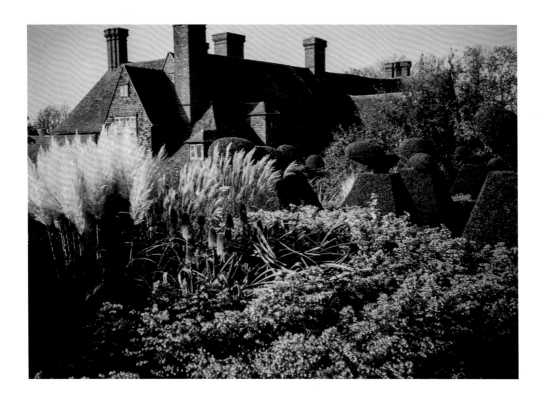

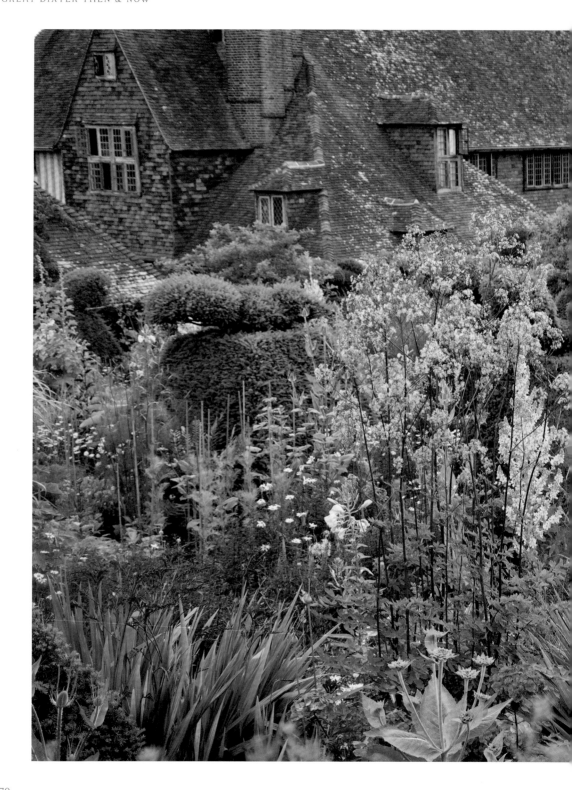

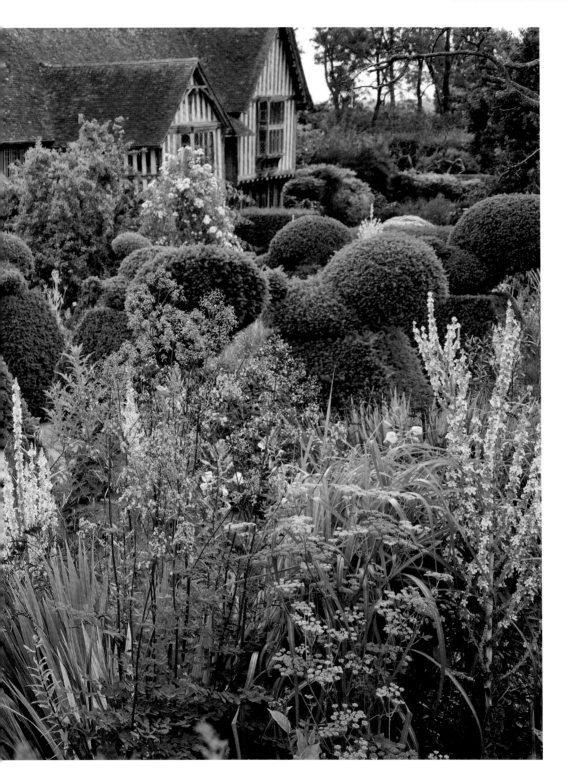

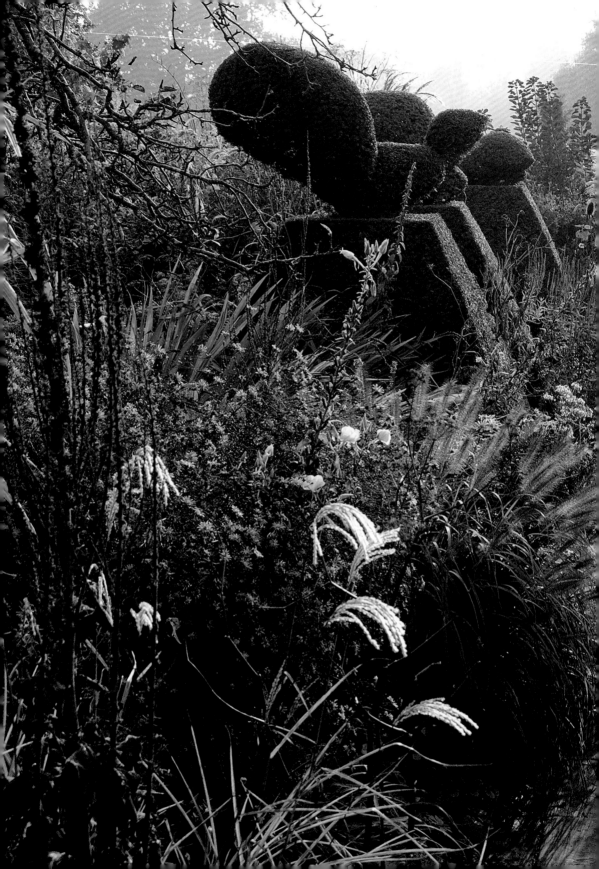

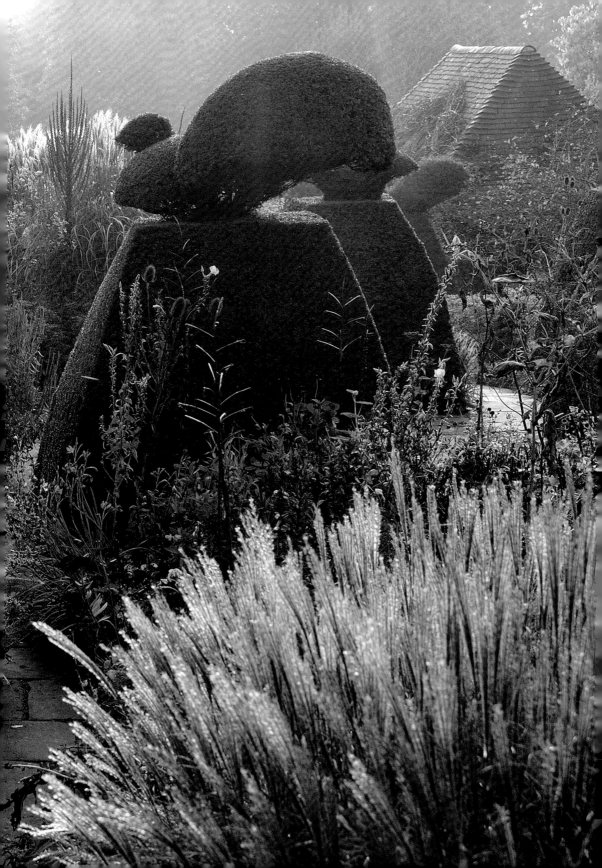

RIGHT Aubrieta along the Kitchen Drive in March 1958. Photograph by Christopher Lloyd.

BELOW The same view in May 2019. Photograph by Carol Casselden.

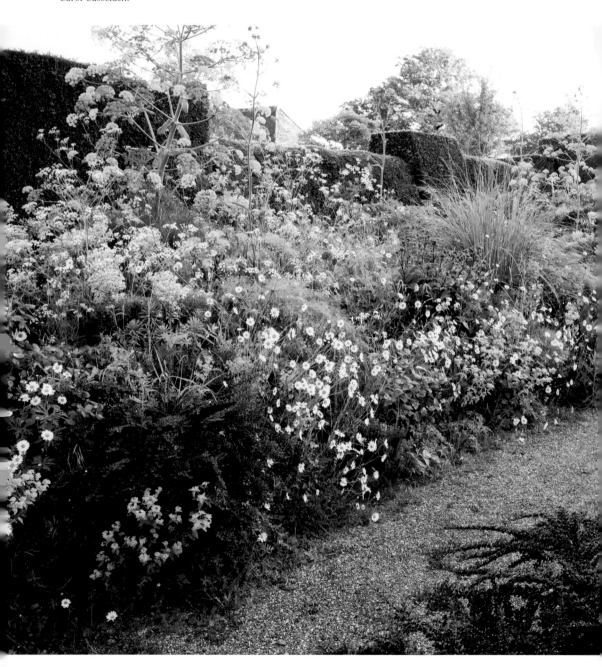

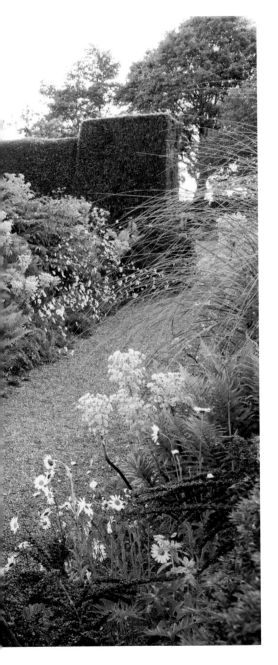

THE KITCHEN DRIVE

The ground on top of the wall above the aubrieta was used as vegetable garden until the 1990s. Instead of rows of artichokes there are now lines of nursery plants. These are mixed with giant fennels and pampas grass and a medley of wild flowers including ox-eye daisies.

The hedge is fatter and the Scots pine is no longer there. The planting areas are now full of tulips for cut flowers followed by nursery stock lined out to grow on. The informality shown in the recent picture makes this area more difficult to manage, but the results are so much more rewarding.

One day the wall will be rebuilt and more aubrieta plants will be plugged into the gaps.

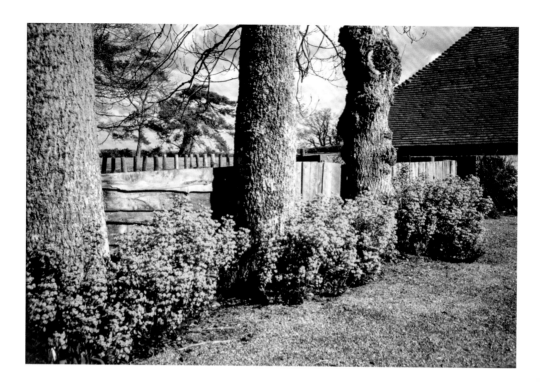

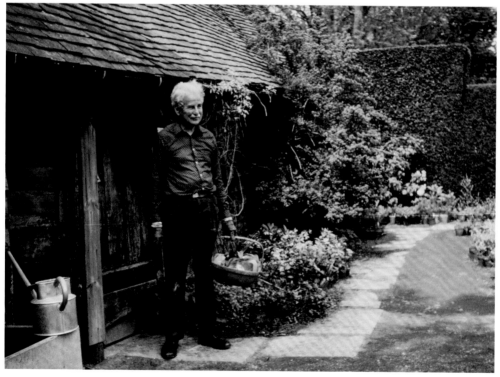

THE NURSERY

LEFT Euphorbia under the ash trees on the edge of the nursery. Photograph by Christopher Lloyd, April 1990.

BELOW LEFT Christopher Lloyd by the potting shed in the nursery, 1980s.

BELOW The nursery edge today. Photograph by Carol Casselden, May 2019.

OVERLEAF The nursery still has its original 1950s cold frames. Photograph by Carol Casselden, June 2019.

Great Dixter nursery was set up by Christopher Lloyd in 1954. He was very much hands-on, doing all the propagation and soil sterilization himself.

The nursery buildings were old farm buildings that had been used for fruit and vegetable storage, with shade provided by the ash trees on the southern side. These are shown with *Euphorbia amygdaloides* var. *robbiae* in the picture from 1990. The trees are still there today, with the euphorbia still at their feet, although the space in front is now used for pots of plants in cold frames ready for sale.

Until the early 1990s a considerable amount of the nursery stock was lifted bare from the open ground in the High and Orchard Gardens. It was then labelled and wrapped up in newspaper. The cold frames seen in the 2019 photographs below and overleaf date from the early days of the nursery and are used for propagation. One greenhouse quickly became three as the nursery developed at the beginning of the twenty-first century. The same soil-based compost formula is used as in Christopher's time (minus the peat, which has been replaced by composted bark).

The nursery remains an old-fashioned place, with many of the plants produced on site and grown and hardened off in the old cold frames.

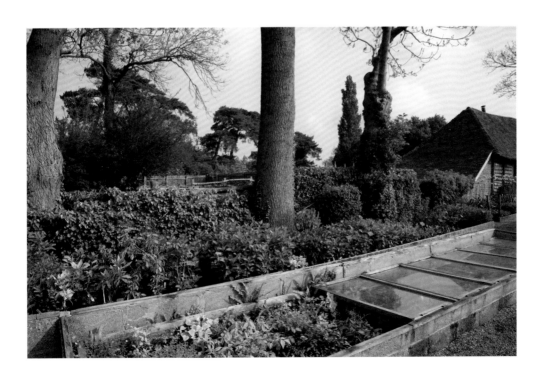

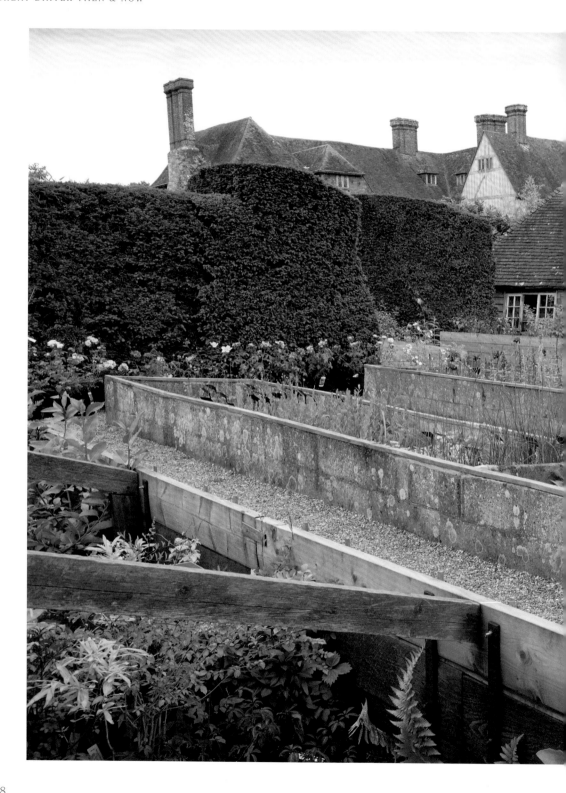

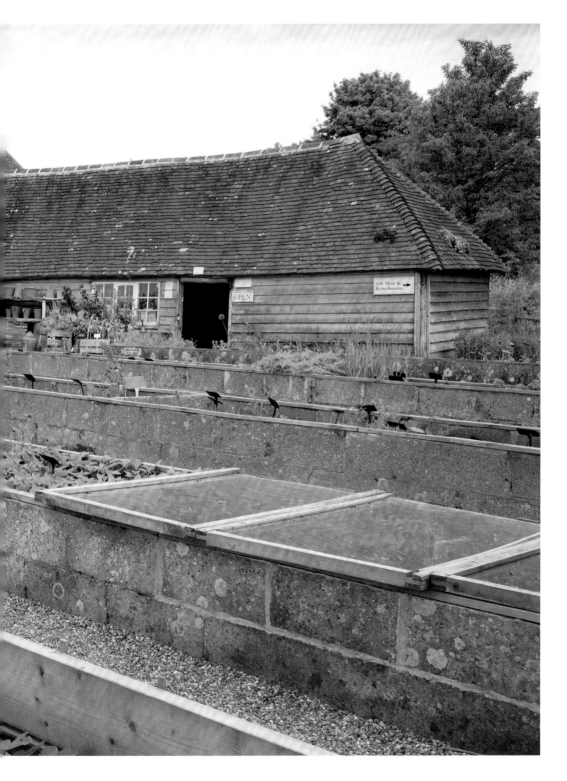

INDEX

Page numbers in italics refer to captions to the illustrations.